HERITAGE, TOURISM, AND RACE

Heritage, Tourism, and Race views heritage and leisure tourism in the Americas through the lens of race, and is especially concerned with redressing gaps in recognizing and critically accounting for African Americans as an underrepresented community in leisure.

Fostering critical public discussions about heritage, travel, tourism, leisure, and race, Jackson addresses the underrepresentation of African American leisure experiences and links Black experiences in this area to discussions of race, place, spatial imaginaries, and issues of segregation and social control explored in the fields of geography, architecture, and the law. Most importantly, the book emphasizes the importance of shifting public dialogue from a singular focus on those groups who are disadvantaged within a system of racial hierarchy to those actors and institutions exerting power over racialized others through practices of exclusion.

Heritage, Tourism, and Race will be invaluable reading for academics and students engaged in the study of museums as well as architecture, anthropology, public history, and a range of other disciplines. It will also be of interest to museum and heritage professionals and those studying the construction and control of space and how this affects and reveals the narratives of marginalized communities.

Antoinette T. Jackson is a Professor in the Department of Anthropology at the University of South Florida in Tampa and Director of the USF Heritage Research Lab. She received a Ph.D. in anthropology from the University of Florida, an M.B.A. from Xavier University in Cincinnati, Ohio, and a B.A. in Computer and Information Science from Ohio State University. Her last book, *Speaking for the Enslaved: Heritage Interpretation at Antebellum Plantation Sites*, was published in 2012 (Routledge).

HERITAGE, TOURISM, AND COMMUNITY

Series Editors: Helaine Silverman and Mike Robinson

Heritage, Tourism, and Community is an innovative book series that seeks to address these three interconnected areas from multidisciplinary and interdisciplinary perspectives. Titles in the series examine heritage and tourism, and their relationships to local community, economic development, regional ecology, heritage conservation and preservation, and related indigenous, regional, and national political and cultural issues.

Heritage that Hurts
Tourists in the Memoryscapes of September 11
Joy Sather-Wagstaff

Speaking for the Enslaved
Heritage Interpretation at Antebellum Plantation Sites
Antoinette T. Jackson

Faith in Heritage
Displacement, Development, and Religious Tourism in Contemporary China
Robert J. Shepherd

Haunted Heritage
The Cultural Politics of Ghost Tourism, Populism, and the Past
Michele Hanks

The Political Museum
Power, Conflict, and Identity in Cyprus
Theopisti Stylianou-Lambert and Alexandra Bounia

Culture, Celebrity, and the Cemetery
Hollywood Forever
Linda Levitt

Heritage, Tourism, and Race
The Other Side of Leisure
Antoinette T. Jackson

Series page: https://www.routledge.com/Heritage-Tourism–Community/book-series/HTAC.

HERITAGE, TOURISM, AND RACE

The Other Side of Leisure

Antoinette T. Jackson

Routledge
Taylor & Francis Group

NEW YORK AND LONDON

First published 2020
by Routledge
52 Vanderbilt Avenue, New York, NY 10017

and by Routledge
2 Park Square, Milton Park, Abingdon, Oxon OX14 4RN

Routledge is an imprint of the Taylor & Francis Group, an informa business

© 2020 Taylor & Francis

The right of Antoinette T. Jackson to be identified as author of this work has
been asserted by them in accordance with sections 77 and 78 of the Copyright,
Designs and Patents Act 1988.

Library of Congress Cataloging-in-Publication Data
A catalog record for this title has been requested

ISBN: 9781629585581 (hbk)
ISBN: 9780367464844 (pbk)
ISBN: 9781003029014 (ebk)

Typeset in Bembo
by Taylor & Francis Books

CONTENTS

FIGURES

PREFACE

This book is about heritage and leisure tourism in the Americas, seen through the lens of race. It is especially concerned with redressing gaps in recognizing and critically accounting for African Americans as an underrepresented community in leisure. There is a diversity of African American leisure experiences and the book exposes the refusal of African Americans to surrender inalienable rights and a determination to pursue leisure, often outside the purview of white power and control. It attempts to complicate notions of travel, leisure, and tourism with respect to race.

This persistent expression of humanity within African American communities is articulated in the stories people tell about overcoming challenges even in the face of racial segregation. It is particularly evident in the ways in which African Americans exuberantly attributed meaning to their leisure experiences within areas where they felt safe and free to express themselves without fear of racial exclusion, dismissal, or punishment. Research on leisure to date has done a minimal job of, for example, exploring the relationship between recreation and the role of the church in African American communities. One way of exploring this intersection involves addressing questions of how communities create and sustain their daily lives within the context of the structural limitations of racism, segregation, and economic disparities. A study of leisure activities has the potential to broaden our understanding of the dynamics of African American culture through analyses of the complexity of experiences of place; interrelationships of entrepreneurial activities and fellowship and creative pursuits and meaning making.

Discussion of the underrepresentation of African American leisure experiences in the context of racial segregation is indeed a critical intervention academically. It also has personal resonance. My parents were born in New Orleans, where they spent a great deal of their childhood and early adult life during the 1940s and 1950s. Growing up, I heard plenty of stories about their leisure pursuits or what

they did for fun as African Americans living in the South. My mom recalls roller-skating with her brother, my uncle; sometimes they would skate outside all day and even go "uptown" to the all-white area of the city near Audubon Park. Although they knew they could get into trouble if caught in the area, they would peer through the green privacy barriers on the metal fences to watch white people playing tennis or swimming. Built in 1928 and billed as the largest swimming pool in the South, the Audubon Park Swimming Pool in New Orleans could hold nearly 2,000 bathers. As I absorbed stories shared by my mother and uncle it was only much later that I realized these places of recreation were segregated spaces. Audubon was a whites-only pool and remained as such until it closed in 1962. It is commonly believed that the pool closed rather than adhere to desegregation orders.

However, focusing on this and other instances in which Black people were excluded from parks and leisure activities is only part of the story. The other part—the part I emphasize in this book—concerns how Black people leisured, traveled, and constructed meaningful and memorable places of fun and relaxation notwithstanding a hostile racial environment. Often, they did so outside the restrictions of 'whites only' establishments and beyond the control of marginalizing gazes. For example, in New Orleans facilities such as the Rosenwald Pool, constructed in 1950, were opened for Black residents because they were not allowed to use white-only facilities. I began to learn about these "other" places of leisure by talking to my parents and other people who grew up in the New Orleans area—particularly during segregation. In 2005 I interviewed a family who lived in the Little Woods area just prior to Hurricane Katrina. I learned that from the late 1930s until the 1960s, Little Woods, also known as Edgelake, was considered a vacation destination and recreation spot for African Americans.

Lincoln Beach, located on Lake Pontchartrain along Hayne Boulevard in the Little Woods area, was designated as a leisure destination for *Negroes* beginning around 1939. It began as the city's answer to the exclusion of Blacks from the nearby whites-only Pontchartrain Beach, which opened in 1928 and remained segregated until 1964 when mandatory integration was instituted. Pontchartrain Beach was larger, had more rides, was centrally located, and was accessible via public transportation. However, between 1939 and 1965, Lincoln Beach was the only beach available to African Americans in that area. In 1954 it was further developed as Lincoln Beach amusement park, which my parents remember well. When I asked my mom if she went to Lincoln Beach, she excitedly answered, "Why yes—that was the only beach for Black people. We went after high school graduation. I will never forget what a great time we had. The rides were great." The year she is speaking about is 1957. Lincoln Beach Amusement Park had rides such as a Ferris wheel, a merry-go-round, and a Whip along with several swimming pools, a restaurant, and a midway. It was also known for hosting famous musical performers such as Fats Domino, Ray Charles, Sam Cooke, Josephine Baker, Tina Turner, and the Ink Spots. In 1958, Lincoln Beach was the site of the Negro State Fair.

In June 2018, on a trip from New Orleans to Mobile, Alabama, I decided to find the site of the old Lincoln Beach amusement park. I found it and was excited and also disappointed. There was not much left to indicate that it had ever reached the stature of my imagination based on the stories I had heard and old pictures I had seen. The only thing that really made me realize that I had found the right spot along Hayne Boulevard off I-10 at the Little Woods exit was the old, faded neon sign pointing to what was once an amusement park entrance. There it hung, sad and tired, pointing into a fenced area. I parked my car and went to the fence to take pictures. Upon closer inspection, all that was on the other side of the fence was overgrowth and patches of trash as far as my eyes could see. There were no relics of abandoned rides; no hint that fun of any kind was ever had there.

Across Hayne Boulevard on the other side of the street was the levee, tall and intimidating. And on the other side of the levee was Lake Pontchartrain. I dodged cars zooming down the Boulevard and went to the levee. I climbed to the top and looked over at the lake. There indeed was water and an area for a small beach. I saw a sailboat and I could see a few people out on the beach but for the most part it was empty. I let my mind wander to the stories my parents had shared and tried to envision a time when this area was full of life, full of people and cars and neon signs that worked; and full of carnival rides, and lifeguards on duty, and laughter. But all I heard was the train as I stood near the tracks at the top of the levee. I strained to hear the water but could not. There was a large concrete tunnel structure below the levee (in the area of Hayne Boulevard across from the rusted neon marker pointing to the amusement park) with an opening where people might have crossed over to the beach side from the amusement park side. But there was a fence blocking the entrance and it was locked. I took pictures, looked at the graffiti on the walls of the tunnel, and got back in my car. I drove up and down that section of the Boulevard a few more times before taking a side street into the neighborhood that bordered the former amusement park. I circled around and tried to find another vantage point to look over the fence encircling the amusement park but unfortunately could get no better view. I found a retention pond in one section of the neighborhood of Little Woods and it smelled badly. For a moment, I stopped my car in front of the foul-smelling pond and looked towards Lake Pontchartrain and the levee, which was about half a mile away in the opposite direction. Then I headed back to Hayne Boulevard and noticed that there was a small "for sale" sign in front of the site of the Lincoln Beach amusement park. I then took one more look up towards the rusting entrance sign to the former park, almost hidden now, and finally headed back onto I-10 to Mobile.

My aunt lived for a time in the Little Woods neighborhood, and we used to visit her when I was young. Back then I thought it was such a big deal to stand on top of the levee. But I did not remember the foul-smelling pond or ever see or hear about the former amusement park, which now I know was right in her neighborhood. I really wish that there was something to mark the spot of the Lincoln Beach

amusement park. Some kind of reminder that Little Woods was the place where Black people went for fun, for entertainment, to swim, and eat and dance. The famous and not-so-famous alike came to Little Woods and Lincoln Beach to have fun. When other parks, like Pontchartrain Beach with its spacious grounds and $100,000 rollercoaster, excluded African Americans, Black people leisured anyway. I am sharing memories, and writing this book, as a marker for the Lincoln Beach amusement park providing information that I wish I'd found on the site.

The history of Lincoln Beach and Audubon Park and the experiences of African Americans at these places should compel us to reframe current debates about the "crisis" of underrepresentation of African American visitors at national parks and other sites of recreation and leisure. I am referring specifically to questions raised by the National Park Service about shrinking visitor numbers overall and the lack of diversity with respect to park visitor profiles. Those concerns have led to numerous studies, articles, and calls to action aimed at addressing the lack of non-white visitors to "our" national parks. I propose that this book, through the application of an ethnographic and ethnohistorical approach to analyze race and leisure, will help reshape and rethink the underrepresentation of "minority" visitors at state and national parks and other heritage places and sites of recreation and leisure. It will do so by providing critical context for addressing where "our" focus should be placed and what other kinds of questions need to be asked to advance a broader understanding of the topic and derive better solutions.

The methods, topics, and arguments in *Heritage, Tourism, and Race: The Other Side of Leisure* are informed by my appointment to the position of Regional Cultural Anthropologist for the National Park Service, Southeast Region from 2012 to 2016. It was during this time that I became intimately familiar with the extensive network of parks, recreational facilities, laws, social practices, interpretations, and normative behaviors that historically enforced "whites only" or white-preferred spaces of cultural activity at national park sites. I contend that far too many national park facilities retain histories of exclusion based on race/ethnicity. Many still fail to locate these complex histories at park sites today; they erase all but the dominant narrative, denying the impact and implications of Indian removal policies and racial segregation practices, for example. Generally, this is due to benign neglect and the lack of political will to critically examine old practices, interpretations, and ways of developing and promoting leisure and heritage.

For instance, I am reminded of Homestead Bayfront Beach at Biscayne National Park in South Florida near Miami. The Biscayne National Park's Dante Fascell Visitor Center sits directly on top of the site of the historically African American Homestead Bayfront Beach, which even had a segregated road for African American visitors to access the beach. When I last visited, there was no marker identifying this history. In 2011/12, Iyshia Lowman, a University of South Florida graduate student, conducted research at Biscayne National Park aimed at collecting oral histories and documenting the lived experiences of African Americans who frequented the beach during the 1950s and 1960s. This work was conducted under my supervision and in cooperation with the National Park Service (NPS) because

they wanted to know more about this aspect of the park's history. The study resulted in the completion of a report for the NPS and the completion of a master's thesis by Lowman about the beach and its history (Lowman 2014). Although the Park initiated the study of Homestead Bayfront Beach, to date Biscayne National Park has yet to incorporate this research into the interpretative materials for visitors to the park (Lowman 2012). When asked why information about Homestead Bayfront Beach was not part of their interpretation of the site, park personnel at Biscayne National Park explained that the topic of segregation and the history of African American experience at the site would be troubling to the park's majority white visitors.

Even though there are some national park sites that work to include the history of Black leisure and recreation, there remain other gaps and more work to do in order to provide an accurate representation of Blacks' participation. At Mammoth Cave in Kentucky, for example, the early history of Black cave guides and early African American tourism at the site are part of the interpretive display at the park's visitor center. However, there continues to be a gap in researching and interpreting the national parks' role in segregation. To address the "crisis" of under-representation in the national parks, it is crucial to tell the stories of these parks in ways that directly address the exclusionary practices of segregation, and foreground how these practices were resisted by the African American community, among others.

I spent over thirty years living primarily in cities in the northeast and Midwest (Washington, Pittsburgh, Columbus, Ohio, and Chicago) before I began living in the U.S. South as an African American adult professional in 1998. As indicated, in the South I became acutely aware of "whites only" or white-preferred boundary markers of cultural heritage with respect to travel, tourism, and leisure and how entrenched tangible reminders of this past remain today. One vivid example is the presence of a 30-by-50-foot Confederate flag that stands along the busy inter-state exchange of I-4 and I-75 in Tampa. Housed on private land since 2008 at a site called the Confederate Memorial Park, this flag is described as the largest Confederate flag in the nation. It waves boldly along a major interstate corridor in the U.S. As a motorist traveling regularly along this path, I cannot miss this reminder of an era in which Blacks were enslaved, disenfranchised, and killed for transgressing racial boundaries. I began my journey in writing this book because I am daily confronted with these realities and I want to contribute to informed public dialogue and action to address the historical implications of segregation based on race as policy and practice today.

As I complete this book, debates about the display of Confederate monuments, memorials, and flags at state and national parks and at government sites are increasingly part of public conversations. In some cases, Confederate monuments of this kind have been removed from public parks and government buildings. In other cases they have not been taken down. The purpose of this book is therefore to continue such critical public discussions about heritage, travel, tourism, leisure, and race in the Americas. Stories such as those shared by my mom are personal and

connect me intimately to this topic and to this book. I use my status and experience as a professional anthropologist to curate an array of stories, experiences, and examples of the ways in which Black people and communities of color more broadly have navigated structural and social barriers to leisure access. In so doing, I aim to show how these communities have actively disrupted preconceived notions of cultural heritage in their knowledge of, and engagement with, the natural environment through an ongoing effort to exert their humanity and basic rights of citizenship in public spaces of leisure.

ACKNOWLEDGEMENTS

I would like to first give thanks to all those who came before me and whose lives have made this book possible. I tell stories many have actually lived. *Ashe'* and eternal respect. There are a few names that I must call out directly because they have been essential. Beginning with family, thank you to my parents, Mercedes and Jesse Jackson, and siblings Gregory, Yolanda, and Jacqueline; and to my extended family, LaFredia Davis, Ricci, Saddan, and Emmy; Deidre, Dan, and India; Donna Wallace; and Oladuni Akanke, Irawo Ifadara, and Salewa Ajamu-McKinney. Special thank you and much love to Dana-ain Davis, whose love, partnership, advice, generosity, innumerable edits, and constant encouragement and passion for me to tell this story is the heartbeat of this book. Many other wonderful people have entered my life at just the right moment and helped me get this book across the finish line by offering special insight, specific expertise, and genuine belief in the project and in me. In this spirit I thank: Rosemarie Roberts, Nate Jung, Mitch Allen, Ms. Theola Bright, Susan Fitzpatrick, and Rachel Breunlin. Also, a big thank you to Sebastian Stuart for the use of his cottage in Saugerties, NY, to write; to Katie and Brian of Beach Side Palms, another great writing space; and to Daryl Thompson for introducing me to his family, the Marsalises, and sharing family stories and history, and for providing digital mapping expertise. Acknowledgement and thank you to Helaine Silverman for editing support, to the Kentucky Library faculty and staff at Western Kentucky University—particularly Sue Lynn McDaniel—for research support and introducing me to local contacts, to the staff at Amistad Research Center Tulane University New Orleans for excellent support and access to a rich collection, and to the University of South Florida Publication Council and the Department of Anthropology for publication funding support, and to Routledge editors and staff for all their work in getting the book into production and published. There are so many others to thank. If you are not named please know I recognize that a village has supported this effort and I am grateful and incredibly blessed.

Antoinette T. Jackson
March 29, 2019

1

INTRODUCTION

The major thesis of this book is that examining heritage and tourism in the United States through the lens of race exposes the ways in which the pursuit of leisure is denied to people who are not white. And yet, I demonstrate that in spite of legally and socially constructed obstacles, leisure and outdoor recreational activities were continuously pursued by African Americans. They did so in public spaces as well as in the privacy of Black-constructed spaces that were designed to welcome the Black community—often out of the sight of the white gaze, and in spite of racial segregation. This book posits that the pursuit of leisure is an assertion of humanity and an inalienable right. Efforts to defend this basic freedom in public and private spaces have historical roots with contemporary implications. The other side of leisure is a recognition that racial exclusion played as much a part in recreational activities as did the refusal to accept it.

This dynamic of exclusion and resistance is epitomized by the circulation of what was known as *The Negro Motorist Green Book,* or *The Green Book. The Green Book* was a travel guide series for African Americans published between 1936 and 1964 by Victor H. Green and his wife Alma D. Green. It provided African American motorists and tourists with information about safe places to eat, sleep, tour, have fun, go to the restroom, and get gas during the era of segregation. The Greens' book explores the other side of leisure and provides *solutions* to the problem of segregation faced by African American travelers during the U.S. period of Jim Crow segregation. The establishment of safe spaces for recreation and leisure by and for Black people was a show of resistance and also a site of power.

The very need for a resource of this kind is key to my book, which sheds light on the stories and histories of people and places you may visit that perhaps you never knew had such histories. These places—parks, churches, stores, cafeterias, and concert halls—were viewed as off limits to Blacks by whites, a sentiment highlighted in a much-discussed 1948 speech by then U.S. presidential candidate

Strom Thurmond. He adamantly declared that the U.S. Army could not force white Southerners to allow Black people into white leisure and social space.[1]

In a December 2002 newspaper column Bob Herbert reminds readers of that speech and writes:

> Strom Thurmond was screaming and the crowd was going wild. "There's not enough troops in the Army," he said, "to force the Southern people to break down segregation and admit the Negro race into our theaters, into our swimming pools, into our schools and into our homes."
>
> *(Herbert 2002)*

Thurmond's speech demonstrates how demands by whites for racial segregation often included leisure activities and not just political enfranchisement (Phelts 1997; Kahrl 2012; Wiltse 2007). A prevailing sentiment among those holding racist ideas about Black people was that Black presence in white spaces was offensive no matter how "well behaved" Blacks were (Candacy 2016). Similarly, when the whites-only Pontchartrain Beach was being established in New Orleans in 1928, white citizen groups protested against Black presence—claiming that the mere presence of Black swimmers would depress property values.[2]

Working from such examples, my book suggests that the reality of the transatlantic slave trade and its aftermath, specifically segregation, remains embedded in the construction of social place in America (Baker 1998; Jackson 2012; Kendi 2016; Orser Jr. 2007). My goal is to craft new ways of thinking about the historical reality of slavery and segregation in the context of leisure, and to make the resulting dialogue part of the public discussion—no matter how uncomfortable.

I focus on the role genealogy, oral history, and ethnography of the everyday play in making African American experiences of leisure visible. I examine the other side of leisure by prioritizing African-descended family histories and genealogies in ways that showcase how African Americans pursued, critiqued, and expanded representations of leisure outside a white-only frame. Specifically, this approach creates other ways of interrogating heritage, tourism, and leisure; and experiences of African-descendant people in the era of segregation that are not indebted to white notions of citizenship and accessibility. Rather, these other ways of knowing are indebted to expressions of resistance, refusal, and the inalienable right to create safe places for fellowship, fun, and exploration unbounded by the limits of racial exclusion.

Locating Exclusion and the Shaping of Place in the Americas

What is at issue is the erasure of historical context and the complex narratives of leisure and place occurring outside of a white normalizing perspective, particularly at national sites of history and heritage authorized for public consumption. Questions such as "Who is allowed to define, create, or enter designated sites of culture and heritage?" and "Who is allowed to partake in leisure activities and where are they allowed?" are central to this discussion.

In a 2013 article entitled "The Civil Rights Movement and the Future of the National Park System in a Racially Diverse America," Joe Weber and Selima Sultana—both geographers—grapple with a question that has become more pronounced and more insistent in recent years: why are there so "few" "minority" visitors (i.e. African Americans, Hispanics, Asian Americans and Native Americans) in the National Park System? Utilizing data from the National Parks Second Century Commission Report (2010), they write,

> Visiting parks has long been a family tradition for Americans and during much of the postwar era visits to parks grew at a faster pace than the population, leading to problems of overcrowding. However, the vast majority of national park visitors are white.
>
> *(Weber and Sultana 2013a, 444–445)*

Weber and Sultana find the predominance of white visitors disturbing because it runs counter to the ideal of the national park system as being built on principles of democracy and freedom. They state, "The future of America's National Park System, as with many valued cultural institutions, requires the increased support of a multicultural population" (Weber and Sultana 2013a, 446). In other words, they propose that attracting underrepresented visitor groups to the park is a social imperative that will save and preserve the system for everyone.

The situation as outlined by Weber and Sultana is certainly compelling. However, I question the need to focus on the number of "minority" (non-white) visitors at national parks as an issue of primary concern. Nor do I think that simultaneously tying the underrepresentation of non-white "minority" visitors at national parks sites to a crisis in the future economic stability of the national park system is an appropriate focus. In both instances the articulated problem—decreasing visitor numbers and the future economic stability of the park system—rests squarely on the underrepresented groups or "minority" communities, which are characterized and labeled as both the problem and the solution to the problem. Instead, processes of exclusion should be more firmly addressed, especially in context with the U.S. national park system and associated histories of discrimination, segregation, and removal of non-white visitors and stakeholder communities.

The case of the Ahwahneechee Indian communities, in what is now recognized as the state of California, is a stark reminder of how expulsion and exclusion shape space in the Americas. Policies and practices aimed at regulating Indian populations in designated Anglo-American spaces have been in effect in California since it became a state in 1850. In 1851, U.S. soldiers expelled the Ahwahneechee Indians from their lands and renamed their valley "Yosemite" (Cronon 1995; Jacoby 2003; Spence 1999). In 1864 President Abraham Lincoln signed the Yosemite Act, making Yosemite one of the oldest designated public lands set aside for conservation. In 1872 Yellowstone National Park was created. In these events, a widely repeated, sequential narrative of national parkland was born and institutionalized: set aside public land; grant federal ownership; *remove* local or existing inhabitants;

and finally, remove usage rights on the land such as for hunting or fishing to preserve the landscape in "pristine" condition—as it was assumed to have existed prior to European arrival.

The same power dynamics in this narrative of Yosemite and Yellowstone are found in the ways in which African American leisure and access to recreation has been structured through a practice of exclusion since transatlantic slavery. National parks practiced segregation based on U.S. laws that upheld racial separation. In their 1896 *Plessy v. Ferguson* decision, the U.S. Supreme Court sanctioned racial segregation as the law of the land. Until passage of the Civil Rights Act in 1964, freedom of movement and the ability to utilize resources in both public and private facilities was legally denied to anyone identified as Black. Spaces such as hotels, swimming pools, public parks, gas stations, and restaurants were designated as white-only spaces.

For example, throughout Southern national parks, including Shenandoah and Great Smokey Mountain, segregated facilities were present (Shumaker 2009; Young 2009). In 1939, Lewis Mountain Negro Area opened at Shenandoah National Park in Virginia. It was in operation as a Black campground through the 1940s. Additionally, the master plan for the Great Smokey Mountains National Park located on border of Tennessee and North Carolina designated "colored" campgrounds in the 1930s. At the Mammoth Cave site in Kentucky there was segregated lodging and separate tours based on race, as well as efforts to remove an early African American presence (Algeo 2013). At Little Talbot Island in Florida, formerly a state park, now part of Timucuan Ecological and Historic Preserve, there were "colored beaches" and white-only lodging (O'Brien 2012). Finally, in Arkansas at Hot Springs Reservation (established in 1832), later renamed Hot Springs National Park (established in 1921), nearly all bathhouses had been segregated by the early 1880s with the establishment of Jim Crow laws. However, around the start of the twentieth century, African American organizations were allowed to build places specifically for Black bathers at Hot Springs National Park. Black-designated sites were located in less prestigious areas of the park, and today sit outside the recognized "Bath House Row" Historic Landmark District (Shumaker 2009). Eventually, in December 1945, the Washington office of the National Park Service issued a general bulletin to all parks that mandated that all facilities in national parks be desegregated.

Meanwhile, the efforts by Blacks to claim spaces distinct from whites often came under scrutiny, censure, ire, and sometimes even sabotage by whites. Although places such as Pitt County, North Carolina, Rosewood, Florida, and Tulsa, Oklahoma boasted leisure activities such as amusement parks, theaters, churches, eating establishments, and swimming for African Americans in the 1920s and 1930s, each of these places were completely destroyed by white fear of Black agency (Ellsworth 1992; González-Tennant 2018; Kahrl 2013).

It is evident from these limited examples that even cultural institutions such as state and national parks, founded on ideals of democracy and justice, faced challenges with respect to race. Today, far too many interpretive narratives of

park and heritage sites fail to reflect the complex story of American history, which includes the challenges of segregation and desegregation. Rather, they focus on heroic stories of white settlement of North America. These heroic stories privilege pilgrims, pioneers, and homesteaders; plantation owners; military heroes and presidents; freedom seekers and explorers. They neglect the technological, cultural, moral, gendered, and racial histories and tensions of engagement with diverse communities (Jackson 2011a, 2011b, 2014; Finney 2014; Shumaker 2009). At issue, however, is not only a need to focus on the history and heritage of African Americans within the national story but also the fact that U.S. policy and legal codes were based on exclusion, which was manifest even in sites like the national parks, designated for public use. And yet this book demonstrates that African American resistance, refusal, and agency in the face of racism and exclusionary laws are underrepresented experiences and knowledges that can significantly enhance interpretive narratives at cultural institutions and heritage sites.

Leisure Scholarship Through the Lens of Race

A wealth of critical scholarship has focused on heritage, tourism, power, and related issues of interpretation, representation, and preservation (Battle-Baptiste 2011; Bruner 2005; Chambers 2010; Handler and Gable 1997; Finney 2014; Jackson 2012; Leone and Potter Jr. 1998; Otero 2010; Polanco 2014; Shackel 2002). One challenge is to learn from and engage with scholarship that shifts public dialogue from a singular focus on those groups who are marginalized and disadvantaged within a system of racial hierarchy to those actors and institutions exerting power over racialized others through practices of exclusion.

Applying a cultural anthropological perspective and looking at social and systemic processes that perpetuate and reproduce racial hierarchies and disparities in travel, leisure, and tourism experiences is one way to proceed. I situate myself alongside other scholars concerned with a critical racial orientation such as Michael Ra-Shon Hall (2014), who interprets *The Negro Motorist Green Book* series as a postcolonial record of power and disenfranchisement; Perry L. Carter (2008), who argues for a mixed method approach to racialized leisure travel; Rashad Shabazz (2015), who examines racializing spaces as Black; Michelle Alexander (2010), who examines race and social control post-Jim Crow; and lastly, the analytical thinking of Katherine McKittrick (2006), Mabel O. Wilson and Rose (2017), and Mario Gooden (2016). These authors have developed a useful body of scholarship around the ways in which Blacks shape geographic and architectural space through labor, knowledge, and movement.

Four leading theoretical perspectives for explaining low numbers of non-white participation (or lack of "minority participation") in recreational activities, particularly outdoor recreational activities such as visiting national parks, have been developed by scholars. They include: 1) marginality hypothesis, 2) subculture or ethnicity hypothesis, 3) assimilation hypothesis, and 4) discrimination hypothesis.

Each hypothesis provides differing explanations of a narrowly defined problem of non-white participation in leisure and recreation activities and different understandings as to whether or how it should be addressed. Taken as a whole, these explanations consistently lack an ethnographic and ethnohistorical methodological perspective. Nor do they engage the resources of critical race theory. For example, the marginality hypothesis focuses on socio-economic constraints or lack—such as lack of money; lack of information; or lack of awareness, about places to visit or to travel (Washburne 1978). The subculture or ethnicity hypothesis argues that different cultural groups have different values and interests. (Washburne 1978). Consequently, these different interests, pursuits, and ideas about leisure are innate and independent of socio-economic factors.

Additionally, the assimilation hypothesis—much like the subculture and ethnicity hypothesis—says that different cultural/ethnic/racial groups pursue different activities with respect to leisure and recreation; however, activities pursued by whites are characterized as the norm and the standard to which other groups (non-white others) aspire. In general, this theory posits that as "minority" groups move to simulate characteristics of the majority group they will come to "appreciate" and assume the values around leisure expressed by the majority group, such as visiting parks (Floyd 1998; Weber and Sultana 2013b).

Marginality, subculture, and assimilation hypotheses typically do not critique the systemic impact of race and racism historically. Nor do they critique differential access to activities and leisure options based on race even though differential access has dominated travel, tourism, and leisure pursuits in the past and continues to do so in the present. Avoidance of race is also evident in advertising campaigns that exclusively associate particular groups with enjoying or engaging in specific activities regardless of a diversity of narratives countering those fixed representations.

This leaves the discrimination hypothesis. This theory primarily focuses on how past discrimination influences current associations for particular groups in terms of activities and approaches to travel and leisure. In short, it addresses the legacy of discrimination and associations with place, access, and mobility. In terms of application by scholars, emphasis is disproportionately placed on those marginalized by discrimination vs. on the construction and maintenance of systems of exclusion—i.e. construction of the notion of the idea of outdoor parks and wilderness as getaway spaces for whites often at the expense of or exclusion of others (Philip 2000). I challenge both the marginalization theory (Blacks lack sufficient resources, income, and information) and the ethnicity theory (Blacks have fundamentally different travel interests to whites). Instead, I agree with Myron F. Floyd (1998), who states that more work needs to be done in advancing the discrimination theory vs. the ethnicity and marginalization theories. It is by placing greater emphasis on a critical race perspective and expanding research to include qualitative and quantitative studies focused on African American travel, tourism, and leisure that the current dialog on issues of underrepresentation will be advanced.

Active Exclusion: Addressing the How and the What of It All

Discussions about African American leisure experiences in the U.S. require a critical race orientation. It is impossible to discuss the failure of parks and other public institutions to attract "minorities" and non-whites in isolation of the impact and implications of Jim Crow segregation. Centuries of American legal policies and social practices have been constructed to deny, exclude, and discourage access by non-whites to full citizenship rights in all spheres of American life and leisure. In order to expand and advance the interpretation at public sites of history and heritage, a critical emphasis should first be placed on understanding *what* African Americans and other underrepresented groups were doing historically in terms of travel, leisure, tourism, and recreation (post-Civil War through 1964) when such a large percentage of whites *were* visiting parks. Leisure scholar Perry Carter (2008) proposes that focusing on the "how" and "what" questions when addressing issues of African Americans and leisure is one way of analyzing systemic exclusion.

I propose that racial and racialized identity is a dynamic process of meaning-making that is fluid, socially constructed, and contested. In this book, I focus on heritage and leisure tourism in two distinct ways. First, from an analytical perspective, I critique the "how" questions of power as expressed through processes of exclusion. Second, I apply a critical ethnographic methodology that attends to the "what" questions of African American heritage and tourism by rendering travel and leisure activities visible through the lens of race.

I propose *active exclusion* as a theoretical intervention for interpreting and critiquing leisure and recreational experiences of African Americans in the context of race. This way of thinking about the role of race in leisure experiences extends the discrimination hypothesis by directing attention to *how* systemic exclusion operated. I situate active exclusion as theory and practice. It is a theoretical framework that contextualizes and interprets African American travel, leisure, tourism, and recreation experiences historically, emphasizing the deliberate nature of the practice of racial isolation and disenfranchisement. As practice, it is performed by state actors and others in positions of power (in public and private domains) to disadvantage Blacks or those deemed inferior within a system of white superiority and supremacy, for example through the implementation of Jim Crow segregation. My definition and application of active exclusion builds upon notions of social exclusion in which the actions of social actors result in the marginalization, exclusion, or denial of rights of full participation in society as equal citizens to people relegated to the status of "other" based on their race/ethnicity (Barry 2002; Silver 2007). A key aspect of engaging this perspective is that it takes into account the associated consequences of such actions over time.

Additionally, active exclusion involves the construction and control of space. Active exclusion is operationalized through multiple domains of power which I term apparatuses. I focus on four—social control, architectural, legal, and geographic. Each apparatus employs a set of processes or very specific measures for producing racial separation and maximizing protection of white space. The idea of

active exclusion proposed in the context of the control and construction of space engages Robert Weyeneth's (2005) definition of the architecture of racial segregation. In Weyeneth's definition, racial contact is minimized or significantly reduced between whites and Blacks by controlling space and designing and organizing the built environment to facilitate this intent. Weyeneth states, "Exclusion, duplication, and temporal separation were the spatial strategies typically employed to isolate the races from each other" (13). These spatial strategies—requiring Blacks and whites to live, work, socialize, and recreate, for example, in two different spheres—dictated everyday life and behavior within U.S. society until 1964 and the passing of the Civil Rights Act.

Much like Weyeneth, my use of an active exclusion framework emphasizes the deliberate nature of the practice of separation and disenfranchisement. Deliberate action was taken by federal, state and local governments and other agents to block, restrict, or constrain African Americans. Deliberate action was taken to control space in order to keep one group of people from exercising their full rights of citizenship in the domain of recreation and leisure. Very specific processes produce the racial separation intended by active exclusion. For example, designation of white-only spaces was marked through signage. In this case racial boundaries were established through use of physical barriers or dividers, such as upstairs/downstairs and front/back, and/or different doors and entrances for whites and Blacks. It also included the creation of duplicate or parallel spaces that were designed, developed, and designated for Blacks, as in "Negro" or "colored" areas. Finally, there were temporal designations that controlled participation in the public sphere that came in the form of "sundown towns" or certain days for Black patrons and Black attendance at events.

The second way that this book contributes to the literature on heritage, tourism, and leisure is methodologically. Specifically, new ethnographic and ethnohistorical research methods and a critical ethnography methodology are advanced. This puts the lived experiences of people at the center of the discussion. For example, I address some of the "what" as well as some of the "why" questions associated with African American travel and leisure experiences, as Perry Carter (2008) proposes be done in his work on racialized leisure travel published in *Tourism Geographies*. Katie Algeo (2013) also points out the need for this work in her discussion of early African American presence at Mammoth Cave. Ethnographic and ethnohistorical research methods provide a means of making day-to-day life within African American communities visible and they provide a means of challenging existing claims, theoretical assumptions, and interpretations about Black travel and leisure that are based solely on quantitative research.

Overall this book attends to the "what" by making the actions of people and communities visible in the face of exclusion, particularly in terms of showcasing knowledge of nature and the environment; entrepreneurship, hospitality; historical associations to place; and expanded notions of gender roles and responsibilities. A qualitative research approach that prioritizes lived experiences is important to this goal because much of the leading scholarship on travel and leisure with respect to

race is done from a quantitative perspective. Currently, an emphasis is placed on numbers versus people (Krymkow, Manning, and Valliere 2014; Weber and Sultana 2013b). A few travel and leisure scholars have called for expanded forms of research such as data collection and interpretation that includes a focus on people that utilizes cultural experiences as a form of knowledge production (Carter 2008; Floyd 1998; Ford 2001; Johnson et al. 1998; Finney 2014; Algeo 2013).

However, what is at issue is not only notions of representation but also systemic processes of exclusion that deny access to public facilities and basic rights of citizenship to the very people, groups, and communities now deemed "important" and even critical to the National Park Service's economic and environmental survival (Finney 2014; Schiavo 2016). It is precisely because Blacks and other "minority" groups engage in heritage tourism, cultural heritage preservation, and leisure pursuits that are often off-stage, backstage, and out of the gaze of the dominant group that I propose greater focus be placed on documenting and learning from their complex and varied experiences. This book contributes to a more nuanced understanding of heritage tourism and leisure through the lens of race and challenges dominant narratives of place through the critical examination of locations and processes of exclusion.

Organization of the Book

This book is about active exclusion and the refusal of Black people to forgo the pursuit of leisure—as an act of resistance and an expression of culture, humanity, and heritage in the face of white denial of Black humanity and citizenship status. This is done in the context of four major areas: 1) recreation and leisure in plantation spaces; 2) unexpected sites of leisure; 3) exceeding segregation limits; and 4) churches as leisure spaces and sites of resistance. Each of these areas brings a critical focus to the "how" and "what" questions around heritage, tourism, and leisure.

This introduction emphasizes the importance of critiquing the role of power in the construction and protection of leisure as a cultural marker of whiteness, including a refusal to recognize, let alone prioritize, the history and humanity of Black people. Subsequent chapters offer specific examples and case studies of the cultural construction of leisure as an expression of African American agency in the face of exclusion in a range of places in the U.S.

Chapter 2 centers on the *Green Book*. It offers a critical view of travel and leisure experiences during the Jim Crow era underscoring the realities of traveling while Black. The focus is on a travel guide series created and produced by an African American businessman and distributed nationally. The goal of the *Green Book* was to help Black people avoid being victims of exclusionary practices and unsafe conditions when they traveled and sought places to sleep, eat, get gas, and have fun.

Chapter 3 concerns the use of former plantation grounds as leisure spaces and asks what this means and for whom. Timucuan Ecological and Historic Preserve (TIMU) is a national park site in Jacksonville, Florida. It has a history that dates back to plantation slavery and earlier. The chapter brings to the forefront tensions

associated with protection of white-only spaces of leisure. As well, the recreational experiences of Black people in association with this national park site are emphasized. I do so by focusing on specific families and their histories, making experiences of leisure for African American visible.

Chapter 4 centers on Mammoth Cave and the African American community of Shake Rag, both of which are in Kentucky. I situate Mammoth Cave and Shake Rag as unexpected sites of leisure where African Americans engaged in a range of recreational pursuits. Mammoth Cave is an example of the history of Black out-door leisure—specifically caving. Shake Rag is a thriving community that served as a haven for recreation and leisure during the Jim Crow era. This area of Kentucky is a testament to the fact that African American people constructed leisure spaces and utilized the natural environment.

Chapter 5 shines a light on the Marsalis Mansion Motel in New Orleans, Louisiana, which was owned by Ellis Marsalis Sr., grandfather of the renowned jazz musician Wynton Marsalis. I draw upon archival data and interviews with family members to tell the story of the now demolished motel. A key aspect of the story is the impact this motel had on the surrounding community during the era of seg-regation. This is a story that explores how Ellis Marsalis Sr. defied and exceeded the limits of segregation and operated his business in spite of repressive legal strictures.

Chapter 6 showcases recreation and leisure in the community of Spring Hill in Tampa, Florida. Spring Hill was central to the tourist industry of Sulphur Springs in the 1920s and 1930s and yet is underrepresented in the history of the area. In this chapter, we find that African American churches in Spring Hill were an important domain not only of spiritual strength in the face of oppression but also in providing spaces for African Americans to engage in a broad range of recreational activities in safe environments.

Notes

1 Numerous sources have recorded Strom Thurmond's speech. See: "Civil Rights Timeline," *Columbia SC 63*, accessed September 27, 2018, www.columbiasc63.com/civil-rights-tim eline/.

2 When the whites-only Pontchartrain Beach was being established in New Orleans (in 1928), there was also talk about what to do about a beach for Blacks. During the 1930s the City of New Orleans considered several options for a Black beach and an area called Seabrook was one option. This was an area near the Industrial Canal and highly pol-luted. But, white homeowners complained, particularly a white homeowners group called the Edgewood Improvement Association. According to Brentin Mock, "The Edgewood Improvement Association, a white homeowners group, complained that the mere presence of Black swimmers would depress property values." See: Brentin Mock, "How African Americans beat one of the most racist institutions: The swimming pool," *The Grist*, May 28, 2014, accessed September 27, 2018, http://grist.org/living/how-a frican-americans-beat-one-of-the-most-racist-institutions-the-swimming-pool/.

2

PLEASE MENTION *THE GREEN BOOK*

Traveling While Black

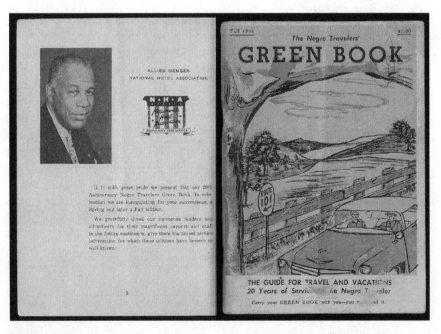

FIGURE 2.1 Victor H. Green (1892–1960) and *Green Book* Cover, Fall 1956
Source: Schomburg Center for Research in Black Culture, Manuscripts, Archives and Rare Books Division, The New York Public Library. "The Negro Travelers' Green Book: Fall 1956" New York Public Library Digital Collections. Accessed March 30, 2019. http://digitalcollections.nypl.org/items/9c454830-83b9-0132-d56a-58d385a7b928.

The Negro Motorist Green Book was a travel guide series established in 1936 by Victor H. Green (1892–1960), a New York postal carrier, and published through 1967 by Green and his wife Alma Duke Green. It provided African American travelers with the information necessary to journey comfortably and safely during the era of segregation.[1] Crucially, *The Negro Motorist Green Book* was marketed as providing *solutions* to the problem of segregation faced by African Americans travelers.

Recreational spaces are markers of culture and who is considered "cultured" as well as indicators of social and institutional norms and hierarchies. They are also markers of citizenship status. Paying particular attention to these markers in the U.S. during the period of legalized racial segregation underscores why travel guides such as the *Green Book* came to offer a treasure trove of knowledge about African American travel, leisure and recreational agency. This chapter revisits the historical realities of traveling while Black 50+ years after the practice of racial segregation was legally ended in the U.S. (in 1964) through a review of *The Negro Motorist Green Book*, hereafter referred to as the *Green Book*.

Life, Liberty and the Pursuit of Happiness

A fundamental marker of American culture and citizenship is articulated in the U.S. Declaration of Independence (1776): "We hold these truths to be self-evident, that all men are created equal, that they are endowed by their Creator with certain unalienable Rights, that among these are Life, Liberty and the pursuit of Happiness." Of course, this was not true because Africans and their descendants were enslaved by many of the signers of this document and were unable to become citizens. Their words are especially relevant to this discussion because they offer a way to rethink or perhaps think more critically about the foundational tenets embedded in some of America's most public places of recreation and tourism, and especially the rights many of us take for granted in our contemporary travel and leisure: for example, access to a car, and the ability to stop, eat, rest, and purchase gas unobstructed. By contrast, signs reading "colored," "white only," and "no Jews allowed" permeated the U.S. social landscape and dictated movement within this landscape during the period of Jim Crow (1873–1964). Uncertainty and denial of access based on race resulted in the development of conscious strategies for travel, particularly for Black people.

Victor Green's travel guides provided answers to the question, "Am I welcome here?" The *Green Book* is an archived record of places that were open to and welcoming of Black travelers. It provides documented insight into African American travel and leisure pursuits over a period of nearly thirty years. The *Green Book* sheds light on the places and ways African Americans traveled in spite of laws aimed at denying them access to leisure spaces and limiting their freedom of movement. Green's book offered the tag line, "Assured Protection for the Negro Traveler." This protection was achieved in collaboration with many business partners—ranging from small family owned facilities, to corporate enterprises like

Esso— in a publishing environment defined by multiple travel guides and through the use of specific marketing strategies.

Partnering with Esso

Whereas many organizations, service stations, and travel guide publications adhered to the status quo of segregation by ignoring the challenges faced by Black travelers, corporations like Esso, the Ford Motor Company (*Green Book* 1947, 1949) and Keller Motors (*Green Book* 1948) advertised in the *Green Book* and targeted African Americans as customers. If nothing else, these companies recognized the business opportunities presented by a growing market of African American travel and leisure consumers.

Esso Standard Oil Company, one of the chief marketers and supporters of the *Green Book* and its clientele, franchised gas stations to African American business owners. Esso was also the primary distributer of the *Green Book* at its gas stations. They hired two Black marketing executives, James A. Jackson and Wendell P. Alston, to help with these efforts and by 1962, the *Green Book* had a circulation of two million (Taylor 2016; Weems Jr. 1998). In the 1949 edition of the travel guide, Alston wrote the following in an effort to encourage usage of the *Green Book* and Esso products:

> As representatives of the Esso Standard Oil Co., we are pleased to recommend the GREEN BOOK for your travel convenience. Keep one on hand each year and when you are planning your trips, let Esso Touring Service supply you with maps and complete routings, and for real "Happy Motoring"—use Esso Products and Esso Service wherever you find the Esso sign.
>
> *(Green 1949, 4)*

Additionally, the 20th anniversary edition of the *Green Book*, published in Spring 1956, was presented with the compliments of Wendell P. Alston, "The Esso Man," and a 1958 special issue of the guide was published by the Esso Men (meaning both Jackson and Allston).

Comparing Travel Guides

There were other travel guides and organized travel groups operating during the same timeframe as the *Green Book*. In fact, there were other Black traveler guides—*Hackley and Harrison's Hotel and Apartment Guide for Colored Travelers* (1930–1931), *Travel Guide* (1947–1963), and *Grayson's Guide: The Go Guide to Pleasant Motoring* (1953–1959). But none matched the circulation and readership of the *Green Book* nor its time span of operation. With regard to other marginalized communities, Victor Green was also interested in Jewish American travel and leisure experiences, in particular the motivations for excursions to the

Catskill Mountains in New York in the 1930s to an area known as the Borscht Belt. Businesses that operated in this region catered to the social-cultural needs of Jewish travelers who also faced discrimination in the U.S. (Adams 1966; Higham 1957; Scheinfeld, Kanfer, and Joselit 2016). In the introduction to the 1949 issue, Green (1949) writes, "The Jewish press has long published information about places that are restricted and there are numerous publications that give the gentile whites all kinds of information" (1).

Travel guides like the series published annually by Duncan Hines from 1936 to 1962— *Adventures in Good Eating* (Hines 1936)—catered to predominantly white clientele in which restaurant and lodging options were not limited according to race.[2] Green's goal, in contrast, was to identify safe spaces for African American travelers—places that did not discriminate on the basis of race.

Inside the Green Book: Content and Layout

Because travel for African Americans was highly strategic during the era of Jim Crow, it is important to consider the rigor in which travel guides aimed at this clientele were constructed. It is particularly instructive to examine the publication details of the *Green Book*. Victor Green wrote in the introduction to the 1948 guide: "There will be a day sometime in the near future when this guide will not have to be published. That is when we as a race will have equal rights and privileges in the United States" (Green 1948, 1). In some ways this introduction proved prophetic with regard to the *Green Book*'s publication history. The *Green Book* was published annually 1937–1941. There was a gap in publication from 1942 to 1946 due to World War II, but publication resumed in 1947 and the guide was published every year from then to 1957 (including both a Spring and Fall edition of the 1956 issue). In 1958, a special issue was published by the Esso Men; then, between 1959 and 1967, the *Green Book* was published each year, with the 1963/64 issue being a combined edition labeled the "International edition." A final edition was published in 1966/67, also as a combined edition. After the passing of the Civil Rights Act in 1964 and the introduction of laws that prevented racial discrimination at hotels and other facilities, the book's usefulness as a tool for travel declined.

The New York Public Library (NYPL) maintains a digitized collection of the *Green Book* series 1937–1967, excluding the 1958 special issue put out by the Esso Men. A careful review of the digital collection is informative. First, the *Green Book* covers reflect the time period in which they were published and the increasing budget and messaging sophistication of the guide. Second, in terms of pricing, over the years the *Green Book* ranged in price from 25 cents for the first edition to 75 cents in 1947, one dollar in 1950, and $1.95 by the 1960s.

Each guide contains a table of contents followed by pages of listings of lodging, restaurants, beauty parlors, service stations, and other establishments. The listings are organized by city within each state or country listed (see figure 2.2, 1940 edition excerpt). There are numerous pictures, graphics, advertisements, and informative articles throughout. For example, the 1940 edition features an article written by A. R.

McDowell, a collaborator with the United States Travel Bureau. The article describes a special bus tour he led in which travelers went from New York to Georgia with various stops along the way. Entitled "Southward," McDowell encourages travelers to take a steamer tour when visiting Savannah. He writes,

> Anyone visiting Savannah between April 1st and October 1st, should by all means take the ride on the steamer among sea islands and through the various inlets to Beaufort, S.C. The round trip consumes about 12 hours. Most of the scenery is wild and primitive, and all of it is beautiful. The cost for the round trip is one dollar. Soon after boarding the steamer for this trip, we noticed a Colored man, exercising much authority. Crossing Port Royal Sound (the only rough water on the trip) looking up at the pilot house, we noticed this man at the wheel, looking ahead and calmly smoking his cigar, a sight seldom seen elsewhere. Negroes have long been associated with navigation in South Carolina waters.
>
> (Green Book *1940, 26–27*)

McDowell's article highlights both an awareness and interest in boating and nature in general by African American travelers. Consequently, we can see that African Americans possessed competence in piloting boats and were clearly participants in the tourist industry as tourists, business owners, and skilled laborers. In addition to such special interest articles, the *Green Book* at times focused on special issues emphasizing certain themes. Some of the themes included the Railroad edition (1951); the National Parks edition (1952); and the Airline edition (1953).

Inside each edition of the *Green Book* there is a request made for patrons to carry and mention the *Green Book* when traveling. In the 1947 issue, the request is framed as follows:

> You will find it handy in your travels, whether at home or in some, other state, and it is up to date. Each year we are compiling new lists as some of the places move, or go out of business and new business places are started giving added employment to members of our race. When you are traveling mention "The Green Book" so as to let people know just how you found out about their place of business.
>
> *(1)*

In the 1955 edition there is a marketing campaign aimed at getting current subscribers to raise awareness of the guide among people they know; specifically, they are asked to provide the name and mailing address of someone they would like to receive a free *Green Book*. The person would then receive a complimentary *Green Book* and their name would be placed on the mailing list for *Green Book* marketing.

The tagline "Assured Protection for the Negro Traveler" is first seen in the 1956 issue of the *Green Book* and appears consistently in subsequent issues. In the 1957 issue (as in the 1954 and 1955 editions), the *Foreword* reads in part:

Modern travel has given millions of people an opportunity to see the wonders of the world. Thousands and thousands of dollars are spent each year on various modes of transportation. Money spent in this manner brings added revenue to tradesman throughout the country.

The White traveler has had no difficulty in getting accommodations, but with the Negro it has been different. He, before the advent of the Negro travel guide, had to depend on word of mouth, and many times accommodations were not available.

Now things are different. The Negro traveler can depend on the "GREEN BOOK" for all the information he wants, and has a wide selection to choose from. Hence the guide has made traveling more popular, without encountering embarrassing situations.

(2)

There is a definite appeal for travelers to use the *Green Book* as a defensive tool in order to avoid embarrassment and inconvenience when traveling until the time when travel options would not be minimized due to race.

Many notable changes with respect to the administration, marketing, and advertising are evident, starting in 1959. For example, the name Alma D. Green first appears as editor and publisher in the 1959 edition, signaling a transition in leadership to a woman and a primarily female staff. Beginning with the 1960 issue, the word "Negro" is dropped from the title. The change from *The Negro Travelers' Green Book* to *The Travelers' Green Book* reflects the cultural and political climate of the times and the expanding reach of the guide. The 1961 issue is the 25th anniversary edition. It cements this sense of change in an editorial entitled "Janus" by Novera Dashiell, the assistant editor. In the article she talks about how far issues of traveling for African Americans have come and how far the publication has come over the years. For example, there was an increase in the number of pages from as few as 10 to 128 pages. She also introduces the staff and highlights the publication's international travel options and listings.[3] She states,

> We are proud to state that the Green Book's appeal and use is not confined to the American Negro traveler only. Our foreign subscription lists cover such places as Canada, Mexico, West Indies, England, and West Africa. The Green Book can now be purchased on certain newsstands in the city and Gimbels' department store.
>
> (Green Book *1961, 4*)

Dashiell ends the editorial by stating that if travel to the moon were to become available, readers should remember that "Just that as always, the *Green Book* lists ONLY the BEST places" (*Green Book* 1961, 4). Quality and customer care are significant aspects of each edition of the *Green Book*, from the first to the last publication.

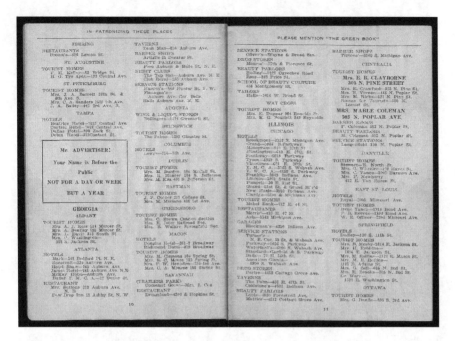

FIGURE 2.2 Lodging listings, 1940 *Green Book* excerpt
Source: Schomburg Center for Research in Black Culture, Manuscripts, Archives and Rare Books Division, The New York Public Library. "The Negro Motorist Green Book: 1940" New York Public Library Digital Collections. Accessed March 30, 2019. http://digitalcollections.nypl.org/items/dc858e50-83d3-0132-2266-58d385a7b928.

The final edition of the *Green Book*, co-published by L. A. Waller and Melvin Tapley, was produced in 1966/67. As described by Jacinda Townsend (2016), the final edition "filled 99 pages and embraced the entire nation and even some international cities. The guide pointed Black travelers to places including hotels, restaurants, beauty parlors, nightclubs, golf courses and state parks." It was titled *Travelers' Green Book, International Edition*. And it confirmed Green's statement that one day there would no longer be a need for the guide. Legalized segregation based on race in the U.S. ended and options for African American travelers expanded following the passage of the Civil Rights Act of 1964.

Green Book Revival

Today there is a *Green Book* revival. Numerous archival projects, cultural testimonies, and re-imaginings recognize the importance of the *Green Book* as a symbol and a tool of African American agency, entrepreneurial spirit, and expression of identity (Kennedy 2013; Sorin 2009). In addition to the NYPL archive discussed earlier, a copy of the 1941 edition of the *Green Book* is housed at the Smithsonian National Museum of African American History and Culture, which also features an

interactive *Green Book* travel exhibit. Finally, the "Mapping the *Green Book*" production blog deals with race, architecture, and landscape in the post-World War II period (Reut 2012). The goal of the project is to map places in the *Green Book* and in *Travelguide*, another African American travel guide.

A controversial film released in November 2018 entitled *Green Book* (directed by Peter Farrelly) won an Academy Award for best picture of the year. Billed as a comedy-drama, it is inspired by the real-life story of Dr. Don Shirley, a world-class African American pianist, on a concert tour in the US South accompanied by a white chauffeur and bouncer hired as his protector in an era of racial segregation and violence directed at Black travelers. Throughout the film emphasis is placed on the unlikely friendship that developed between Dr. Shirley and the chauffeur, with only passing references to the use of the Green Book to locate lodgings during their trip.

In addition to these formal projects, the *Green Book* lives on through the stories people share about travel, tourism, recreation, and leisure as experienced during segregation (Driskell 2015; Ford 2001; Foster 1999; Pauly 2017). For example, in a Delaware Public Media *History Matters* segment which aired in June 2017, Megan Pauly interviews Don Blakey about his experiences with segregation as a Delaware State University student in 1954 (Pauly 2017). Blakey describes how white-only beaches like Rehoboth were off limits to Black guests. But he was happy to find out about the Rosedale resort and hotel, which was owned and operated by African Americans and listed in the *Green Book*. He would work at Rehoboth beach and then go to Rosedale beach to have fun (Pauly 2017). On NPR's *Talk of the Nation* show, host Neal Conan (2010) interviewed Civil rights leader Julian Bond about his memories of his family using the *Green Book* to travel in the South. And many more continue to be shared and archived.

Finally, *The Green Book of South Carolina* (2017) is an innovative new web application that reimagines the publication for the contemporary moment. It is a free mobile travel guide to South Carolina African American cultural sites created by the South Carolina African American Heritage Commission that highlights over 300 places to visit. According to the website, in order to be included in *The Green Book of South Carolina*, sites must be on the National Register or have a State Historic Marker. The site states, "This contemporary homage features tourism destinations that impart a new Southern experience, sharing the compelling story of African American heritage in the Palmetto State" (*The Green Book of South Carolina* 2017). The project harkens back to the role that Victor Green's travel series played in raising awareness about African American travel and leisure interests. In looking back at the *Green Book* today, there is cause for celebration that the guide is obsolete. However, the *Green Book* remains a record and reminder of the centrality of race in African American travel histories. And its contemporary resonance affirms the need for a critique of the realities of race in discussions of African American travel and leisure experiences.

Examining mobility and recreation through the lens of race provides an unflinching view of the ways in which access has been historically denied to people

identified as Black in the U.S. The *Green Book* is a tangible reminder of the challenges posed by segregation to citizenship and freedom of movement for African American travelers during the Jim Crow period of American history. It is a testament to African American actions and ambitions in the face of exclusion that provides historical context for how African Americans experienced travel between 1937 and 1967. Ultimately, the *Green Book* helps address the *how* and *the what* questions of African American travel and leisure in ways that should inform future analyses of and projects on the subject.

Notes

1 After their marriage in 1918, Victor Green and Alma D. Green (1889–1978) lived in Harlem New York in an apartment located at 580 Nicholas Ave. The travel agency office—Victor H. Green & Co.—was located at 200 W. 135th Street Harlem New York 30, New York. See, for example: Gretchen Sullivan Sorin, "'Keep Going': African Americans on the Road in the Era of Jim Crow." Unpublished PhD dissertation, State University of New York at Albany, 2009.)

2 Duncan Hines published the *Adventures in Good Eating* series between 1936 and 1962—see the 1945 edition online with University of Michigan and the 1959 edition online with University of Wisconsin-Madison. He also published a few other guides, including: *Lodging for a Night* (1938); *Duncan Hines Vacation Guide* (1948).

3 The 25th edition of the *Green Book* (the 1961 edition) features a picture of the founder Victor H. Green, Editor Alma D. Green, and the majority female staff, including: Novera Dashiell (Assistant Editor); Dorothy Asch (Advertising Director); Evelyn Woolfolk (Sales Correspondence); and Edith Greene (Secretary). J. C. Miller (Travel Director) is not pictured.

3

PLANTATIONS AS LEISURE?

Timucuan Ecological and Historical Preserve
Jacksonville, Florida

Timucuan Ecological and Historic Preserve (TIMU) is a national park site in Jacksonville, Florida. A location of recreation and tourism today, it has a history that dates back to plantation slavery and earlier. In this chapter I emphasize how the active exclusion of African Americans from designated white-only spaces challenges assumptions about leisure as a social expression of freedom and mobility that was universally or equally available. There are significant gaps in critical analyses of recreational experiences of Black people in association with national park sites like TIMU. In response, I employ the active exclusion framework and focus on the role race, genealogy, and oral history play in making such experiences visible. Utilizing a genealogical approach, I underscore the ways in which African descendant communities construct family, navigate race, and talk about segregation in their leisure and recreation experiences.

Active Exclusion: The White-only Framing of Leisure

In general, white leisure and recreation experiences and the needs of white visitors and patrons during the Jim Crow era are privileged over African American experiences. Consequently, there is a pressing need for counter narratives of leisure (Giltner 2008; Jackson 2019; Kahrl 2012; O'Brien 2012). Therefore, this chapter identifies the other side of leisure by arguing that African descendant families pursued and expanded leisure outside of white-only frames during the era of segregation. The history of TIMU affords an opportunity to examine the implications of racial segregation policies and practices on three families associated with the site—the Christopher family, the Daniels family, and the Kingsley-Sammis-Lewis-Betsch family. Their family histories and lived experiences help illuminate how active exclusion operated through the apparatus of social control. In subsequent chapters I highlight ways in which active exclusion operated through other domains

of power—architectural, geographic, and legal apparatuses. But here I focus on Jim Crow as a system of social control that informed the construction of racial isolation and was essential to the formulation of active exclusion. A key aspect of social control is that it is a form of social organization in which behavior is learned, regulated, and penalized in order that the structure and expectations of society be maintained. Sociologist A. B. Hollingshead (1941) writes: "From the viewpoint of social control, society is a vast multiform, organized system of appeals, sanctions, prescriptions, usages, and structures focused upon directing the behavior of its members into culturally defined norms" (220). Placement within the structure is based on race: those classified as not-white are subordinated; whiteness is protected; and racial separation is normalized. I posit that the history of the park and the family histories reveal how the apparatus of social control was applied with the aim of disenfranchising and subordinating African Americans.

My discussion of TIMU is situated within the context of the history of segregation in Florida. Until the passage of the Civil Rights bill in 1964, for example, life for African Americans in Florida—whether living on Fort George Island or elsewhere in the greater Jacksonville area—was in many ways an extension of the restrictive dictates of slavery and plantation life. In other words, second-class citizenship was pro forma. This could be seen in the form of strict codes and expectations of behavior ("Black codes"), restrictions on mobility and access ("Jim Crow"), and escalated violence and control tactics that included lynching, bombings, and Ku Klux Klan (KKK) patrols. These actions were directed towards the entire socially defined racialized grouping of people labeled as "negroes"—regardless of class or status or place of origin (Aptheker 1951; Cutler 1905; Finkelman 2014; Jackson 1967; Myrdal 1944; Patrick and Morris 1967, 57, 78–81). Tensions associated with managing the geographical and social barriers associated with segregation and exclusion are embedded in Jacksonville's history and in the memories of many of its residents.

Mr. Walter Whetstone, an African American businessman and lifetime resident of Jacksonville, born in 1937, gives insight into the city's racial tension. He offered a personal account of the Ku Klux Klan marching through its streets:

> They were marching down Florida Avenue, and that's the way it was. This was like in the '40s [1940s] and '50s [1950s] … . I never forget that. I had one time the opportunity to see the grand dragon come down the Avenue and I got up under the house. The houses were built way up off the ground, almost so that you could walk under them, [and I] saw those guys coming. But you did not get in the way of the Ku Klux Klan because they would … . And they dominated the situation, and that's the way it was at the time. And it was accepted. The police force and everybody else, either they were Klan men or they were soft toward the Klan men.
>
> *(Whetstone, see Jackson with Burns 2006, 34)*

In addition, ordinances such as Section 269, "Sale to White and Colored over the same counter forbidden," issued in May 1887 at the time of the city of

Jacksonville's incorporation, further highlight the absurdity of racial segregation and discrimination policies and disfranchisement practices which were directed at African Americans in the state of Florida (Odom 1911, 106). Such policies and practices impacted the identity, kinship, landownership, labor and laboring roles, mobility, and even access to sites of recreation and leisure such as at state and national parks particularly for African Americans (O'Brien 2007, 2012).

In the presentation of three family profiles and their associations with TIMU which follows, I provide a view of the other side of leisure. The histories used here also serve to illuminate how the deployment of specific processes of racial isolation and separation were used with intent. These processes, such as partitioning, duplication, and temporal separation, are defined by Weyeneth (2005) and expanded upon in chapter 1. Examining TIMU helps situate the dehumanizing consequences of active exclusion, helps identify the processes used in implementation of the apparatus of social control, and helps foreground what African Americans did in response to or in resistance to these forms of control.

Timucuan Ecological and Historical Preserve Overview

The TIMU site covers 46,000 acres, approximately 75 percent of which are waterways and wetlands. It was established as a national park site in 1988. Its mission is to protect the natural ecology—the complex salt marsh/estuarine ecosystem—and over 6,000 years of human history along the St. Johns and Nassau rivers, and to provide opportunities for the public to appreciate these resources (National Park Service 1996). TIMU, which includes the Kingsley Plantation and the Talbot Islands, is intertwined with the history, heritage, and culture of Jacksonville, Florida. It played a significant role in the area's history during the plantation period (1763–1865) and in the transition to the recreation and tourism period, post-Civil War (Stowell 1996; Jackson with Burns 2006). Discussions of hotels and clubs constructed on TIMU preserve land on Fort George Island during the 'recreation era' (extending post-Civil War to mid-1950s) are today prominently showcased on the park's website and in other NPS publications. Though the Fort George Hotel and the Fort George Club are no longer standing in their original form on park grounds, the lore of leisure as white remains the focal point in such publications. At the same time, discussions of segregation and active exclusion of non-white patrons from these facilities are typically absent from public interpretation of this site (Jackson 2019). And, African American labor, a critical part of the leisure story at these hotels and clubs, remains an under-analyzed aspect of the park's interpretation during the recreation era. This was particularly true of African American women's laboring roles.

The Recreation Era: Transition from Plantation Life and Slavery

The recreation era at Timucuan Preserve is interpreted in terms of a transition from agriculture to recreation at the conclusion of the Civil War. Kingsley Plantation,

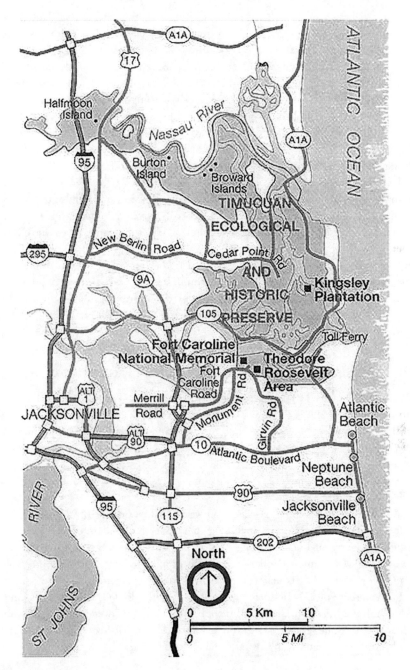

FIGURE 3.1 Map: Timucuan Ecological and Historic Preserve

Source: National Park Service, www.nps.gov/timu/planyourvisit/maps.htm. Or see: National Park Service, Timucuan Ecological and Historical Preserve, Kingsley Plantation–Ribault Club Interpretive Draft Environmental Assessment, Figure 1–1 location map.

one of the jewels of the TIMU Preserve, is named after one of the plantation-era owners—Zephaniah Kingsley. The plantation marks, and is marketed as, a focal point of postbellum transition. It is located at the northern tip of Fort George Island at the Fort George inlet. Zephaniah Kingsley Jr. purchased the plantation in 1817 and owned the plantation until 1839 when he sold it to his nephews (Jackson 2003; Jackson 2019, 10). The 51-acre property is composed of four main buildings: a) the plantation house built circa 1797/8; b) a frame kitchen house built circa 1798 and enlarged in 1814; c) a tabby barn built circa 1824; and d) the frame Fort George Club building built in 1926/27 for recreational use. The original structure burned in 1936 and was rebuilt on the original foundation in 1938 (Jackson 2019, 10).

In 2001 I led a research effort to complete an ethnohistory study of the Kingsley plantation community for the National Park Service. We spent time with and interviewed families in the Jacksonville area. I will focus on three—the Christopher, Daniels, and Kingsley-Sammis-Lewis-Betsch families—each of which has ties to Kingsley Plantation and the history of TIMU.[1] The stories of these families were documented in detail and published in ethnohistorical study of the Kingsley Plantation Community (Jackson with Burns 2006). They provide different insights into the ways African-descendant families experienced recreation in the face of segregation.

The Christophers: Fish Camps, Farmers, and Family Historians

The Talbot Islands played a major role in the early landscape and settlement of what is now TIMU. They also played a major role in the life and history of the Christopher family. Noted fishermen, seamen, and farmers, the Christophers have lived along the St. Johns River and have made a living from the river beginning since the arrival of the first Christopher, Spicer Christopher and his wife, Mary Greenwood Christopher, to Talbot Island in the late 1700s (Jackson with Burns 2006, 54).

When John F. Rollins purchased Kingsley Plantation in 1869, he moved his wife Hannah and children, including Gertrude Rollins, into the Zephaniah Kingsley Plantation house. Rollins continued large-scale agriculture on the island until the 1890s. Some members of the Christopher family who lived on Talbot Island worked for the Rollins family at the Kingsley Plantation.

In the fall of 2001, I conducted interviews with Mildred G. Christopher Johnson (born in 1926), Altamese E. Christopher Dorsey (Mildred's sister), and Inez Christopher Asque. Marion Christopher Alston described her quest to document the history of her family and its importance in this way:

> Well, [what] I hope to achieve [is] to have the Christophers' history—true history put back in the history books and tell it the way it really was because in doing my research, I have gone through and have found lots of errors So I would like to make sure that we could get it corrected, put it into the

history books because our great grandfather was a well-known, respectable man. And I would like to do that. I would also like for my family members to know their family—who they are from—who they came from—who we are.

(Alston, see Jackson with Burns 2006, 54)

The portrait that emerges of the Christopher family's early connection to Fort George Island and the Kingsley Plantation community is informed by those interviews and by documents and information collected by Christopher family members prior to 2001. Marion Christopher Alston, Mildred Christopher Johnson, and Anita James conducted research between 1986 and 1994 in order to produce a family history album. They searched libraries, historical societies, national archives, census data and church records, newspapers, and cemetery records for information on their family. Their research produced an informative family album detailing the history of the Christopher family in north Florida going back as far as the 1800s. The album, entitled *The Christophers and their Descendants,* was distributed to family members at the 1994 Christopher family reunion (Alston 1994).

Their family history shows that the Christophers established the first Black Fish Camp and Marina in north Florida. In doing so, the Christopher family contributed to the economic and social progress of the city of Jacksonville. Christopher-owned establishments provided a space for recreation and entertainment especially for Black citizens of the community. According to family accounts, in 1917, Joseph Christopher opened a fish camp that later became Christopher's Pier—a restaurant and night spot open to Black patrons that offered a variety of entertainment options. Christopher family records contain the following information:

> The first Black fish camp and marina in North Florida was established in 1917, in New Berlin by Joseph A. Christopher. Later the fish camp became 'Christophers' Pier,' a restaurant and night spot for Black residents, sponsoring annual Easter Monday, Labor Day and 4th of July boat races, ski shows, swimming contest and other aquatic activities. Before New Berlin was renamed, it was known as Yellow Bluff.

> *(Jackson with Burns 2006, 55)*

Fish camps and other outdoor recreational pursuits and forms of leisure for African Americans are not frequently examined in outdoor and nature literature (Mason 1998; Foster 1999; Dawson 2006; Giltner 2008; Kahrl 2012; Fletcher 2015; Taylor 2016). Located in out-of-the-way places, these camps were a form of escape and locations of freedom from social pressures and challenges of segregation for African Americans (Foster 1999; Fisher 2006; Kahrl 2012; Fletcher 2015).

Fish camps in northeast Florida were a familiar and popular form of recreation. In fact, Florida is one of the leading states for fish camps. In Jacksonville, these camps were located along the Intracoastal Waterway and rivers—particularly the St. Johns River, which flows north to the ocean in the Jacksonville area and is known for bass fishing. Sometimes described as places for men to hang out, go fishing, set

FIGURE 3.2 Christopher family reunion album cover
Source: Photo by author, September, 2011.

up camp and lodging on site, tell stories, and clean and eat the fish they caught, these fish camps have undergone several evolutions. Many grew into comprehensive entertainment sites and included restaurants and lodging that accommodated families. Fish camp offerings included lodging (typically in small family-owned establishments), places to rent or launch boats, food and restaurant facilities, bait and tackle shops, and other recreational and water sport activities. During the Jim Crow era, fish camps and their associated restaurants and motels were racially segregated and subject to laws prohibiting Black and white customers from eating in the same establishment or lodging in the same facility. Black fish camps are representative of what Weyeneth (2005) calls an imaginative response to segregation. They resisted the imposed process of separation of Blacks and whites, seen in the very existence of parallel or duplicate processes, by producing structures that

catered to the needs of Blacks denied access to white-only spaces offering the same services (Weyeneth 2005, 33).

Local newspapers periodically recount the history of African Americans and recreation during segregation (Soergel 2018a), including Christopher family history. For example, Tim Gilmore (2016) described the location where Christopher Pier once stood as a place to be remembered and one that brings back many memories for people in Jacksonville. The address of Christopher Pier, according to City Directories, was 4310 Apollo Avenue in New Berlin and was "one block from the river, and a swimmer's length from Goat Island" (Gilmore 2016). Junior Hodge, who Gilmore interviewed for the article, was a good friend of George Christopher and had lived for a year on Goat Island as a young man. Hodge describes how George Christopher owned and managed Christopher Pier from around 1950 after taking over from his father, Joe Christopher, who opened the spot in the 1930s. Hodge called George a "sharp businessman" and said he remembered thousands of people coming to Christopher Pier for boat races. These races, which George arranged, were sponsored by beer companies. Hodge also remembered beauty contests being held at Christopher Pier. Other accounts tell the story of Rollie Christopher and Goat Island, which today is called Blount Island. Several newspapers have run articles about Rollians Christopher, also known as Rollie, who lived on the island for years and was known for having hundreds of goats (Soergel 2018b). In the 1950s Rollie refused to leave Goat Island, even under court order, in protest at the shipping industry's threat to develop Goat Island and build a canal. Although he was later arrested and the land was ultimately developed by the shipping industry, his stance made news.

Another aspect of the Christopher family history concerns their racial genealogy and the ways in which their racial identity was consequently defined and articulated. A key memory in the sharing of family history is that the Christophers married whom they pleased regardless of laws prohibiting marriage between whites and Blacks. Sometimes family members changed the public reporting of their racial identity to protect their families. In the U.S. Census the Christophers are classified racially as white, Black, and mulatto. Mildred Christopher Johnson recounted the following:

> My father was Joseph A. Christopher Sr. He was born on Little Talbot Island, his foreparents landed in Maine, and two of the brothers came to Talbot Island, and he was born there in 1876, his mother was a Black woman, his father was a white man, John Christopher. What happened, John's two former wives were white and they had died and my grandmother took care of his kids and they later married and they had 9 kids, and my daddy was the third of the children that she had for him. Her name was Caroline Crockett.
>
> *(Johnson, see Jackson with Burns 2006, 54)*

Census reporting clearly shows racial categorization as being arbitrarily determined and assigned by census enumerators, which is made more evident when viewed in relationship to Christopher family oral history.[2]

One thing that is striking about the Christopher family is their total awareness of the race dynamic and racial politics of the time. They acknowledged racial diversity in terms of kinship. Within the Christopher family, it was a point of pride that they did not let anyone dictate who they could marry or who they could love—they were proud of this defiance of racial norms (Alston 1994; Jackson with Burns 2006, 53). The Christophers refused race restrictive social controls and Jim Crow social structures. I interpret their refusal of race and racially limiting structuring within the context of Audrey Simpson's use of ethnographies of refusal (Simpson 2007). Simpson says there is a need to disrupt narratives of sameness and complicate the dialog showing how people acted in opposition (Simpson 2007, 68). The Christophers did not play by race rules and social controls governing behavior and social interaction, and they directly affirmed their choices.

In sum, the Christopher family connections to TIMU and Kingsley Plantation extend as far back the 1800s. Christopher family members either worked on the Kingsley Plantation or owned and managed neighboring plantation homesteads. More significantly, Christopher landownership patterns, laboring roles, and recreational and leisure pursuits were intertwined with and advanced by the ways in which they navigated and circumvented racial dictates via their marriage and kinship choices and associations. This can be seen through historical accounts and in descendant discussions of family history (Jackson with Burns 2006; Landers 1999; Stowell 1996).

The Daniels Family: The Fort George Club and Kingsley Plantation as Playground

> I've been coming to Fort George Island since I was four years old. That was 1948. They had big parties at the clubs and the island catered to high rank military officials. The Fort George Club founded by Victor Blue is what brought my mother to work on the island.
>
> (Daniels, see Jackson with Burns 2006, 55)

Many new stories shared by James Daniels (such as in the opening quote) about his family provide insight into Fort George Island specifically from the perspective of an African American family's associations with the island. These stories help link National Park Service accounts of the island to the everyday lives of people whose labor supported recreation activities during an important era of park history (Jackson 2019).

During the 1920s, the Kingsley Plantation property was acquired for private use by a community of residents interested in vacationing in the area. The Fort George Club and several other buildings were constructed at the time. These new buildings co-existed with the plantation structures already on the property. In the 1930s the Fort George Club encountered increasing debt and went into financial decline. Then, in 1947, the club voted to open itself up to the general public. By 1948 the remaining members voted to suspend operations and to find a buyer for the

property. The property was then virtually abandoned until 1955, when the Florida Park Board purchased the Fort George Clubhouse and its immediate surroundings. They later purchased the Ribault Club in 1989 (Stowell 1996; Davidson 2007). In October of 1991, the National Park Service took possession of the Kingsley Plantation complex. Today, the Fort George Clubhouse structure has been adapted for use as National Park Service offices, a visitor center, and a bookstore.

The primary mention of the Fort George Club as a hotel and club is found on the "Recreation Era" page of the TIMU website. During the 1920s, two clubs were built on the island—the Fort George Club, which was adjacent to the Kingsley Plantation house, and the Ribault Club, which was built on the empty lot that was once the site of the Fort George Hotel. Although the Fort George Hotel, the Fort George Club, and the Ribault Club were established as white only, predominantly male spaces, to date the description on the website makes no mention of this (National Park Service 2018b). Moreover, there is no mention of segregation or of the segregated facilities on Fort George Island (Jackson 2019).

According to Daniel Stowell's account in his historic resource study of TIMU, John Stuart purchased land on the east side of Fort George Island in 1876 and built a two-story vacation house, which he named "Nelmar" for his daughters, Eleanor and Marian (Stowell 1996). In 1899, Eleanor married Rear Admiral Victor Blue (1865–1928) of the U.S. Navy. Victor Blue was a hero in the Spanish-American War and founder of the Army and Navy Club, chartered in 1923, on Fort George Island. Eleanor and Victor moved into the Nelmar house, known today as the Stuart-Blue house, in 1919. Following her husband's death, Eleanor continued to live in the Stuart-Blue house until World War II (1941–1945). Then her son Victor Blue Jr. (1914–1971) and his family began using the house as a summer home after the war. Stowell speculates about the lives and history of the support staff —the cooks, maids, chauffeurs, groundskeepers—that worked at the recreational clubs and facilities on the island during what he calls the "Recreational and Development" era of Fort George Island (1996).[3]

In an interview and on a tour of Fort George Island, James Daniels shared many stories about his family connection to and memories of Fort George Island (Jackson with Burns 2006). For example, James' mother, Mrs. Johnnie Mae Daniels, was a cook. First she worked for the Fort George Club, then later she was employed by Mrs. Marian Terry who was Eleanor Blue's sister. Mrs. Daniels lived on Fort George Island and was therefore away from her own family during the weekdays. James, who had been coming to the island since 1948 when he was child, shared the following:

> When my mother worked for the Club, she lived in a bungalow just north of the Kingsley Plantation house, it has been torn down for quite some time. During the school year, I stayed at our home in Jacksonville with my daddy to go to school. We came out here on the weekends and in the summer. Kingsley Plantation was the playground of my childhood.
>
> *(Daniels, see Jackson with Burns 2006, 55)*

Daniels' observation of his mother's work gives a view of the Fort George Club during the recreation era from the perspective of a family one of whose members labored for the club. Daniel came to Fort George Island with his father on the weekends and during the summer to spend extended time with his mother and be together as a family. The other side of leisure, in this case, shows various forms of social control. First, Blacks worked in places that they would never be able to patronize. And second, leisure time for white patrons often meant the separation of Black families or reduction of family time within Black households. This was particularly the case for Black families with women who labored for wages by supporting the recreation experiences of white families.

During the interview, Daniels also described Kingsley Plantation house and grounds where he played as a youth in the 1950s and early 1960s. In sharing his story, Daniels not only articulates how he created leisure at a former plantation site but also critiques what it meant to use the plantation as his playground and see shackles embedded in the brick wall in the basement of the plantation house. He shared this memory:

> The Kingsley house was always locked, I never went in it in those days, but I played all around the house and peered in all of the windows. There was main floor, a downstairs and an upstairs. I can't find the window that I looked in each time now because the basement has been covered over. It was not a frame basement back then. It was brick and when I came up to the house I'd always run around to the north side bay window, the windows to the basement were the same size as the windows above. I'd look in the north basement window and I saw shackles. Down there they had actual shackles that were in tack and imbedded in the brick walls. There were two sets of steel shackles that held the wrists and the legs of slaves. My daddy told me that this was where the slaves were taken to be beaten and that they were shackled to the walls. This was always a sadness to see the shackles … . Through the years I'd look at the shackles right on through the 1960s. Then in 1974, I went to see the shackles, they weren't there.
>
> (Daniels, see Jackson with Burns 2006, 57)

James Daniels also talked about other people and places on the island. In his oral history account, James describes his family's associations with Victor Blue Jr (who is described above) and family in this way:

> There were few houses on this island in the 1950s, just woods and mosquitoes. Victor Blue and his wife had a house as big as a hotel on this road [Fort George Road]. At times Mrs. Terry stayed with them even though she had a bungalow on the opposite side of the island near the Kingsley Plantation house. The house that Victor Blue owned was just a few hundred yards south of the Ribault Club. The Admiral's house was called 'Nelmar.' It looks a lot today as it did then, but there was a screened veranda. There were three

homes behind the Blue's house for the caretakers. My Uncle (Mama's brother) Burcher Odoms and his wife lived in this one [points to one of the three]. Mr. Blue was a nasty person to work for. Mrs. Terry was altogether different and most kind. We liked her. She sent me cards and birthday presents right up until she died in the late 1960s.

(Daniels, see Jackson with Burns 2006, 55)

When he was young, James Daniels wanted to swim. He did so in Victor Blue's swimming pool, which was in the backyard of Blue's house. In his interview James describes what happened:

I remember one summer day Mrs. Terry let me swim in the pool.
There were two pools over here, the pool house is still there, but over on that concrete pad to the north of the house was the other pool—that's the one I swam in. But the next day after I went swimming, Victor Blue [Jr.] drained the water from the pool. He couldn't keep Mrs. Terry from letting me get in the pool, but he could empty it and he did.

(Daniels, see Jackson with Burns 2006, 55–56)

Victor Blue's response to a Black boy, the son of the woman who worked for him, swimming in his pool was to drain the pool and seal it with concrete. James did not understand at his young age that an unspoken boundary existed. This story highlights what happens when norms of racial separation are breached under a Jim Crow system of social control. In this example, the specific process of racial segregation used is what Weyeneth labels partitioning (Weyeneth 2005, 22). This is separation within a shared space using barriers that can be fixed or malleable, marked or implied. The application of partitioning in this case was at first unmarked but was nonetheless a social barrier that prevented a Black child from using a white person's pool.

James Daniels' portrait of the Kingsley Plantation, the Fort George Club, and Fort George Island complicates the history recreation at TIMU and locates it outside a white-only understanding of leisure and use of space. He frames the recreation era from the perspective of a working-class Black family's history and through an account of their labor, which supported the leisure activities of white patrons.

Kingsley-Sammis-Lewis-Betsch Family: Interpreting Segregation at American Beach

The Kingsley-Sammis-Lewis-Betsch family offer an intimate portrait of the Kingsley Plantation and community including direct family connections to Zephaniah Kingsley and to the recreation era of TIMU history (Jackson with Burns 2006; Jackson 2011b). However, what is most relevant to this discussion is that the Kingsley-Sammis-Lewis-Betsch family's history and profile of recreation and leisure during segregation affords a view from an African American family's perspective.

Although this was a family of relative wealth, they were still required to navigate white-only spatial geographies and develop responses to segregation.

The central theme of 'the Zephaniah Kingsley story' is his acknowledged spousal relationship with Anta Majigeen Ndiaye (Anna Kingsley), a West African woman described as being of royal lineage from the country of Senegal. Zephaniah enslaved Anta as well as openly acknowledging her as his wife. He established a home with her at his plantations in East Florida and later in Haiti.

Anna and Zephaniah Kingsley had four children, George, John, Mary, and Martha. Mary Kingsley Sammis and Martha Kingsley Baxter each married wealthy white men from the New England area and settled around Jacksonville, Florida. George Kingsley and his brother John Maxwell established households in the Dominican Republic, at that time known as Haiti (Jackson with Burns 2006; Jackson 2011b). In 1884, Abraham Lincoln Lewis married Mary F. Kingsley Sammis—daughter of Edward G. Sammis (Edmund), a former Duval County justice of the peace and the great granddaughter of Zephaniah and Anna Kingsley (Phelts 1997, 28). The Abraham Lincoln (A. L.) Lewis and Mary Sammis Lewis union formed one of the most prominent dynasties of wealth, influence, and power in Florida's African American community.

One of the founders and later one of the presidents of the Afro-American Life Insurance Company (the "Afro"), A. L. Lewis became one of the richest men in Florida during the 1920s until his death in 1947. He amassed large amounts of property in Jacksonville and throughout Florida, and operated many successful business ventures. The 36-acre Lincoln Golf and Country Club, which opened in 1929, is one example (Phelts 1997; Jackson with Burns 2006). In the 1930s, A. L. Lewis and the Pension Bureau of the Afro-American Life Insurance Company decided to develop American Beach—a total beach community for African Americans—as a counter to racial segregation policies enforced in the Deep South state of Florida. In a 2001 interview with the author, Ms. Marsha Phelts explained the importance of American Beach to the African American community:

> My family is from Jacksonville, and so American Beach is an extended part of the Jacksonville community. It's just 30–40 minutes to an hour away from Jacksonville and this is where Black people came during my growing up and my youth for the beach. This was the beach. Even though the coast is[in] Duval County has a beach coast, but that was not available in the 40s and in the 50s—only in 1964 were Blacks able to go to the beaches, and all of the beaches were open to them. I was born in 1944, so I would have been 20 years old if it hadn't been an American Beach for me to come to. Because of this beach I have been coming to the beach my whole life.
>
> *(Phelts, see Jackson with Burns 2006, 30)*

A. L. Lewis' family, as well as others in the African-American community, owned homes on American Beach. For many years this beach resort community on the Atlantic Ocean served as the hub of recreation and entertainment for African

American families and civic and social organizations throughout the South. Prior to the establishment of American Beach, African Americans in the Jacksonville area frequented Pablo Beach. Pablo Beach, which is now Jacksonville Beach, opened in 1884 and was only available to African Americans on Mondays (Phelts 1997; Soergel 2018a). This restrictive access to white-only beaches and recreational facilities that designated certain days and times of use for Black people is representative of racial isolation. This process of restricting access and enforcing racial isolation is what Weyeneth terms temporal separation (2005, 18). In temporal separation, time is used as a form of segregation.

During an interview in 2001, Dr. Cole, an African American-identified, seventh-generation descendant of Anna and Zephaniah Kingsley and great, great granddaughter of Abraham Lincoln Lewis and Mary F. Kingsley Sammis, describes her American Beach experiences in this way:

> I do remember the beach very, very well, the trips there, everything from playing in the sand dunes with my sister to jumping the waves. I remember the extraordinary presence of Black folk having a good time on a Sunday, the buses rolling up, church after church. To go there now obviously is to see the absence of so much that was a spirit of life. And to go there now is just to be eternally grateful to my sister [MaVynee Betsch] for all that she does to, with almost inhuman hands, to stop the encroachment on that beach. And when the big Afro picnics would happen once a year, I have just gorgeous memories of my father making his own barbecue sauce and barbecuing there … . It was in my view what community could really be about, that is folk caring for each other, sharing what they had, going beyond lines of biological kinship to feel a sense of shared values, and one must say also, to feel a sense of shared oppression. Because it was clear to everybody that while A.L. Lewis in his wisdom and with his wealth had made sure that that beach was available, not just for his family, not just for the Afro, I mean people now live in Virginia, in North Carolina who remember coming to that beach. But everybody knew that we were on that beach and could not be on the other beaches.
>
> *(Cole, see Jackson with Burns 2006, 31)*

Today, a museum started by Dr. Cole's sister, MaVynee Betsch, interprets the story of the beach. MaVynee Betsch, now deceased, was an environmental activist and Amelia Island resident known as "The Beach Lady." American Beach clearly underscores implications of active exclusion. It is also an example of a process for responding to racial isolation through the creation of alternative spaces for Black people to enjoy leisure, which in many cases can be considered duplication. Specifically, as a result of racial ideologies of the Jim Crow era and the push to maintain white-only spaces, numerous new constructions resulted in the development of two parallel universes (Weyeneth 2005, 28, 33). Thus, a beach resort for Black people, American Beach, and all-white beaches and facilities in close proximity. It was not lost on Black people that even in their enjoyment of American Beach and

its full-service recreation facilities, they were not allowed to recreate in nearby white-only facilities. Most of the adaptive use efforts or production of new segregated facilities were done for the benefit white people, often using public funds. The financial burden during Jim Crow disproportionately fell on African Americans, who had to build recreational and leisure facilities available to Black people without such support (Weyeneth 2005).

In his thorough documentation of the history of the Florida Park System, William O'Brien advances the need for interpretation of places like Little Talbot Island, now part of TIMU, to include the history of Jim Crow and the exclusion of African Americans from parks and beaches through creation of duplicate facilities separate from whites (O'Brien 2007, 162).

In interpretations at TIMU to date, African American experiences and associations are typically discussed outside the context of white recreational experience. For example, in the case of American Beach, segregation is interpreted via the TIMU website solely as something Black families overcame as opposed to American Beach being a place that Black families enjoyed *in spite of*, and as an alternative

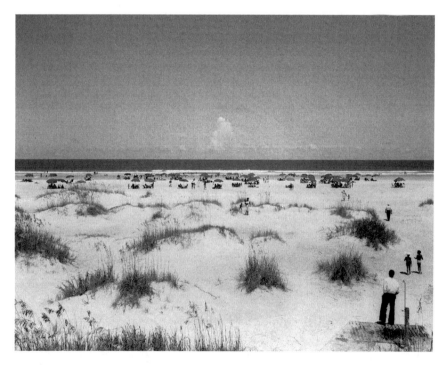

FIGURE 3.3 View of the segregated beach at Little Talbot Island State Park, Jacksonville, Florida (19—) "Scene from the colored area"
Source: Harmon, William Z., 1916–1974. View of the segregated beach at Little Talbot Island State Park, Jacksonville, Florida. 19—. Black & white photoprint, 8 x 10 in. State Archives of Florida, Florida Memory. www.floridamemory.com/items/show/117186, accessed March 31, 2019. Image number: FPS0968.

space in response to, exclusion from other beaches and lodging options designated as "white only."

This chapter broadly advances the theory of active exclusion through the apparatus of social control. The active exclusion framework exposes ways in which social control on the part of individuals and institutions was used to perpetuate marginalization and disenfranchisement of Black people historically. Michelle Alexander (2010) describes systems of social control, such as Jim Crow, as operating as a tightly networked racialized system of laws, policies, and customs that work collectively to subordinate a group based largely on race (Alexander 2010, 13). Identifying and naming the specific processes used to facilitate racial isolation of Blacks from whites further underscores ways in which social control can be more critically understood at TIMU and in Jacksonville for people, families, and communities. These stories and lived experiences brought to the forefront tensions associated with the maintenance and protection of white-only spaces of leisure and implications, such as Victor Blue Jr.'s draining and cementing his swimming pool in order to construct a physical barrier that denied Black access. At the same time, it underscores the multiple ways in which African Americans engaged in recreation and leisure activities, particularly outdoor activities, from fish camps to beaches to swimming to playing on former plantation grounds in the face of segregation. The examples presented disrupt the association of leisure exclusively with whiteness in complex ways.

Notes

1 Oral history, interview testimony, and genealogical information conveyed by descendants and local area residents help to frame the plantation and associated community within discussions of recreation and leisure. Participant observation and key informant interviews for the purpose of collecting oral history were the primary means of obtaining ethnographic field data about the Kingsley Plantation community. Interviews were conducted as part of an *Ethnohistorical Study of the Kingsley Plantation Community* primarily with persons of African descent ranging in ages from 20 to 86 years old. These interviews were conducted either by myself or by people working in direct support of the project under my supervision. Research was conducted at the Kingsley Plantation site and throughout the greater Jacksonville, Florida area, including American Beach on Amelia Island.
2 Researching family history via census recordings, oral history, and other ethnographic accounting of family and kinship associations exposes arbitrary racial classifications by census enumerators at the individual and family level. The subjective and variable nature of racial classification practices, for example, is reflected in instructions given to U.S. census enumerators at the turn of the century (U.S. Census Bureau 1918, 207).
 Many families such as the Rollins, Kingsleys, Christophers and Greshams (Grishams, Grissums) remained on Fort George Island and surrounding islands (i.e. Talbot Islands) following the Civil War. See, for example, the 1880 census excerpt (Jackson with Burns 2006, 52). See also: U.S. Census Bureau 1880 and excerpts transcribed by Antoinette T. Jackson (Jackson with Burns 2006, 74–76).
3 For additional information on laboring roles and families such as Bartley, McQueen, Christopher, Stuart, and Blue, see the 1920 U.S. Census for Duval County, Florida. Also see Jackson's excerpts of the 1920 Census (Jackson with Burns 2006, 76–77).

4

UNEXPECTED SITES, DESTINATION KENTUCKY

Mammoth Cave and Shake Rag

In early May 2017, I flew into Nashville, Tennessee, drove to Bowling Green, Kentucky, and got a hotel room on the campus of Western Kentucky University (WKU), home of the Hilltoppers. My purpose was to visit Mammoth Cave, which is about an hour away from the campus. Mammoth Cave is one of the largest caves in the world and was used by early Americans for thousands of years prior to European arrival, although that fact did not figure in the 1981 UNESCO designation of the site as a World Heritage Site.

During my four-day stay I learned about the role African Americans played in developing cave routes and working as guides and hotel proprietors at Mammoth Cave. Fortuitously, I learned that the historic African American community of Shake Rag in Bowling Green was located just minutes from my hotel room.

Mammoth Cave and Shake Rag are "unexpected sites" of recreation and leisure—for me, they represent the other side of leisure as an encounter with little-known aspects of Black leisure activities, in this case in Kentucky. Such encounters challenge preconceived or narrowly constructed notions that Blacks do not engage in leisure activities or have a limited range, particularly in terms of outdoor recreational pursuits. These unexpected sites represent another way of narrating African American leisure experiences and the challenges of navigating segregation.

Throughout my visit I spoke with people concerning my quest to learn about African American travel and leisure options and experiences in the time of Jim Crow. One woman told me that she had grown up in Jonesville, another historical African American area of Bowling Green. And most of her activities and recreation were centered around the church, which she emphasized had a lot of resources—a library, plays, movies, and a skating rink. There were outdoor activities, boys swam in the river, and there was a playground area. One thing that stood out was her comment that she did not notice segregation because parents in the community sheltered children from this reality. When asked about Mammoth Cave, she said

that she took day trips to Mammoth Cave in the 1950s as part of Vacation Bible School. Mammoth Cave at that time had separate tours for Black people but the park was open to Black visitors.

In addition to conversations with locals, I spent time in the archives, both at WKU in Bowling Green and at the National Park Service (NPS) site at Mammoth Cave.[1] Of course, I also consulted the *Green Book* in order to understand the landscape and options for Black travelers who may have traversed some of the same grounds in the past. The first mention of Mammoth Cave is in the 1938 issue of the *Green Book* prior to NPS ownership of the site. Then, the 1952 National Parks edition of the *Green Book* lists Mammoth Cave Hotel for the first time as part of an NPS-owned site offering lodging. Subsequent issues of the *Green Book* (1959–1964) also list the Mammoth Cave Hotel. Together, these issues position Mammoth Cave as one of the few national park sites at that time that *welcomed* Black guests. National parks were federally mandated to desegregate lodging and concession facilities in 1945. However, a listing in the *Green Book* meant that African American travelers were able to obtain accommodations that *they* found acceptable during their stay. In addition to the Mammoth Cave Hotel, the *Green Book* also lists restaurants and lodging for African Americans in Shake Rag—particularly Nancy's Tea Room and the Southern Queen Hotel.

Active Exclusion Inscribed in Architecture

This chapter provides a view into *how* active exclusion operated as an apparatus inscribed in architecture with a particular focus on the Mammoth Cave area. As previously mentioned, in his article "Architecture of Racial Segregation" historian Robert Weyeneth documents in detail how white supremacy was expressed, reinforced, as well as resisted in architecture. One way that active exclusion manifests in this context is through what Weyeneth calls architectural partitioning (2005, 13). The primary purpose of racial isolation is to preserve white-only space and minimize contact between Blacks and whites. In 1892, the state of Kentucky mandated separate seating between races for rail travel and partitioning was an accepted means of facilitating segregation of races (Weyeneth 2005, 28). The organization of railcar seating, such that there were different cars designated for Black travelers, is but one example of an architecture of racial segregation: the planned construction of spatial isolation based on race.

Examining an architecture of racial segregation means looking at how race is embedded in the physical building of things such as construction and movement within the built environment. It also means looking at just how detailed and integral the system of Jim Crow segregation is in terms of structures and the structuring of places like schools, neighborhoods, churches, and parks. It is interesting to consider Mammoth Cave in this context of active exclusion. This is because caves are a natural formation while the built environment is a human-made structural development (the railroad cars, for example). Although caves occur in nature, typically as formations unplanned by humans, racial segregation was

implemented within this natural formation. One way was through a process labeled temporal separation, in which time was used to segregate (Weyeneth 2005, 18). In the case of Mammoth Cave during the period of Jim Crow, people toured the caves as segregated groups. White groups toured at one time, Black people toured at another time. And, like the process of partitioning used in the example of train cars, temporal separation was another process by which racial segregation was achieved.

This chapter also provides insight into what African Americans did to disrupt systemic processes of racism and active exclusion as an apparatus inscribed in architecture. In order to reach an understanding of architecture as an apparatus of segregation from this perspective, I draw upon the work of architects and architectural historians who discuss architecture as more than a focus on physical entities (Davis II 2018; Gooden 2016; Wilson and Rose 2017). For instance, Gooden (2016) and Wilson and Rose (2017) define architecture as focusing on what goes on inside as well as outside of buildings and human-made structures. In their work, issues of architecture and identity are foregrounded.

In his book, *Dark Space*, Gooden (2016) examines how architecture shapes and is defined by Black identity. More specifically he articulates ways in which Black people define spaces that they inhabit. He brings into public dialog ways in which Black people imprint on places they occupy. This in turn reveals how places have imprinted on Black lives and defined who they are as people, families, and communities. However, this formulation of architecture and Black identity is often not part of the conversation surrounding leisure/leisure studies, outdoor recreation activities, and tourism.

In this chapter I explore one imprint of Black identity—the genealogy of one family and the knowledge of caving that they passed down from one generation to the next. The imprint of Black identity and caving underscores what Gooden (2016) describes as a relationship between architecture and identity making which might also serve as a form of resistance, or a counter narrative, against simplistic discussions of racial segregation.

Architecture as a discipline is about erecting buildings and structures. But it is also about the curation of space and the deliberate planning, organization, and management of labor to create something—a new form of access or a way of residing in or moving through a particular place. Architects Irene Cheng, Charles L. Davis II, and Mabel Wilson (2017) argue that we need to expand what goes into archives to do with those who create such spaces to include architectural knowledge and the labor of non-white people. This can be achieved by making the history of Black people as builders, authors, and curators of space more visible and relevant in scholarship on race, place, and leisure. Mabel Wilson calls for shifting the focus from architecture as building or buildings to discussions of where people live and how they move through the spaces they inhabit (Wilson and Rose 2017).

I take up Wilson's charge with respect to Mammoth Cave and Shake Rag. The community of Shake Rag, like many others built during Jim Crow, was

constructed as a haven against racial segregation. It consisted of stores, churches, restaurants, lodging, hotels, educational facilities, and places for outdoor activities that welcomed and catered to Blacks. Mammoth Cave and Shake Rag demonstrate how Black people lived and organized in the face of active exclusion and what they did to strategically move through the spaces they inhabited.

In this chapter I set out to accomplish three things: 1) provide a history of the caving community and of Mammoth Cave; 2) focus on the intergenerational, familial genealogy of the Bransfords, a family that helped create Mammoth Cave as a site of tourism and leisure; and 3) offer an overview of the Shake Rag community underscoring how it stands in relation and/or contestation to the issue of active exclusion and the idea that Black people did not participate in outdoor leisure activities. I begin with Mammoth Cave.

Mammoth Cave

The history of Mammoth Cave is rich as well as disturbing. Segregation casts a shadow even in light of the active role Blacks played in establishing caving at the site. The first National Conference on Parks, organized by NPS Director Stephen Mather in 1921, increased the development of state parks. The motto of the ensuing state park movement called for a state park location within easy reach (every hundred miles) for Americans, particularly men and women living in cities and urban centers (O'Brien 2007; Landrum 2004). However, the movement's goals and policies to provide access to the great outdoors to all citizens did not in most cases account for nor include African Americans. For example, in 1952, only one state park in Kentucky—Cherokee State Park—existed for African Americans. The 1953 edition of the *Green Book* featured the city of Louisville and a discussion of its parks. Cherokee is described as "a beautiful new park built exclusively for Louisville's Negro residents and tourists. It is located on Kentucky Lake near Eggner's Ferry Bridge" (Green 1953, 27).

While the state of Kentucky did allow African Americans restricted access to sites such as Mammoth Cave, the National Park Service had legislated total desegregation of lodging and concessions by 1945 and stated that its facilities were open to all (Library of Congress 1945). But what, for example, is the history of African American caving activities in the area of Mammoth Cave before and after NPS ownership? How was segregation manifest and what were the processes that served to solidify active exclusion? And lastly, how do Mammoth Cave and Shake Rag, as sites of leisure, complicate how we understand African American experiences in the pursuit of leisure, particularly with respect to nature?

Touring Mammoth Cave

The site is quite expansive and it is easy to get lost even above ground. Mammoth Cave National Park, a unit of the National Park Service, was established by Congressional Act on May 25, 1926 and dedicated on July 1, 1941. The stated purpose

of the park was to protect the scenic, geological, biological, and historical resources within its approximately 53,000 acres. The area that is now the park has been occupied and used by humans for roughly 12,000 years. The archeological record reveals that ancestral peoples inhabited the present-day park lands as far back as 4,000 BC, or even earlier. Seven Federally Affiliated Tribes claim the Mammoth Cave area as their ancestral lands.

From the onset of European arrival in the Americas to the first laboring in saltpeter mines during the War of 1812 to the organized touring of the caves after the War of 1812, Black cave guides dedicated their lives to Mammoth Cave. They led countless visitors through the caves, first as enslaved Africans, then as free men post-Civil War. Explorers as well as guides, men such as Stephen Bishop, Ed Bishop, Ed Hawkins, and the Bransfords (a family of cave guides spanning five generations) discovered new passageways and educated visitors of all ages and all levels of expertise on the unique resources and features of Mammoth Cave (Algeo 2013).

Three early guides are particularly important in the history of cave touring at the site. Stephen Bishop, Mat Bransford, and Nick Bransford (who were associated with the same plantation owner but hold no documented blood relationship), all enslaved, were leased by their owners and sent to work at Mammoth Cave in 1838. They left a legacy of Black entrepreneurship as well as a love for and deep knowledge of the outdoors at one of the world's foremost caving systems. For example, after enslavement, the Bransford family owned a hotel and led paid tours for Black and white patrons.

Historical Overview

European exploration began in Kentucky during the early 1700s. After the end of the French and Indian War, King George III issued the Land Proclamation of 1763 that established the whole of present-day Kentucky as an Indian reservation. The cave was known to pioneer settlers by 1798. And sometime during this period, it was discovered that saltpeter could be produced as a result of mining nitrates from cave soil, which provided ample supplies to meet the needs for gunpowder production of the settlers (National Park Service 2019).

The War of 1812 placed the saltpeter-producing caves of south-central Kentucky in the forefront. Prior to the war, saltpeter was imported from India and other countries for powder mills in the United States. Because of the need for resources available within the U.S., Mammoth Cave played a major role in the war effort. A workforce of approximately seventy enslaved laborers worked in shifts inside the cave to excavate the cave soil from expansive deposits throughout the many known passages inside the cave. When the war concluded in February 1815, the demand for domestic saltpeter plummeted, along with the price. As a result, saltpeter mining operations at Mammoth Cave closed. However, the saltpeter works—the vats, pipelines and pump towers—were left in place and mostly preserved by the stable temperature and humidity of the cave.

Following the War, Mammoth Cave became famous as a place to visit and view the mining equipment and the large cave that housed it. By 1816, Mammoth Cave was being promoted as a tourist attraction. The first guide, Archibald Miller, a former manager of the saltpeter mining operation, was assigned to lead visitors through the cave. To house these visitors, the first Mammoth Cave Hotel was initially formed from several small one-room cabins which were originally built on the ridge near the Historic Entrance to house enslaved workers. In 1916, the first Mammoth Cave Hotel burned down, and the second hotel was constructed in 1925. It remained in place until demolition in 1978/79, after being declared a fire hazard. The third, and latest, hotel was constructed in 1965 and designed to visually complement the National Park Service Visitor Center, which was constructed 1959–1961.

In 1838, Mammoth Cave was bought by Franklin Gorin, a Glasgow, Kentucky lawyer. Gorin brought several of his enslaved African laborers to Mammoth Cave, some to work in the hotel and some to guide visitors and hotel guests through the cave. These three early guides were the aforementioned Stephen Bishop, Mat Bransford, and Nick Bransford. Stephen Bishop was the most famous of the three. It was said that not only did Bishop quickly learn the existing tour routes, he also began to explore on his own. Bishop is credited with discovering many important passages and features of the cave.

Bishop and the other enslaved guides were eventually sold in 1839 as part of the Mammoth Cave Estate to Dr. John Croghan, a physician from Louisville. Croghan invested time and money into enlarging and modernizing the hotel, and built new roads to provide better access to the cave. Croghan's efforts benefited from Bishop's knowledge of the caves; Bishop became famous and was widely sought-after by visitors to guide their tours. He even drew a map of Mammoth Cave from memory based on what was known at the time. His map is accurate in terms of the relationship of passages to one another and provides a substantive perspective of the cave. It is on sale today at the NPS Visitor's center as a souvenir. When Croghan died in 1849, his will stipulated that Bishop be granted his freedom seven years after his death. Bishop and his family were freed in 1856. Stephen died in 1857 and is buried, along with other guides, in the Old Guides Cemetery.

From approximately 1816 until the 1930s, Mammoth Cave and numerous tracts of land outside the Estate were privately purchased by families and developed as farmland. It is estimated that over five hundred families settled north and south of the Green River in the area surrounding the Mammoth Cave Estate; many of these families were African Americans and descendants of enslaved Africans that had worked in the saltpeter mines and caves.[2]

Mammoth Cave: Bransford Family View

I present this profile of the history of caving from the perspective of the Bransford family's genealogy to illustrate the imprint Black people have made and to offer a view into the politics of spatial orientation and resistance (Gooden

ATLANTA
 Hotel Shaw—245 Auburn Ave.
 James Hotel—241 Auburn Ave. N.E
 McKay Hotel—Auburn Ave.

**Butler Y. M. C. A. 22 Butler St.

GEORGIA

(ATLANTA)
TOURIST
 Mrs. E. B. Jackson 49 Davis St. N. W.
Night Clubs
 The Top Hat—Auburn Ave. N. E.
Restaurant
Mrs. Suttons 312 Auburn Ave. N. E.
Barber Shops
 Artistic 55 Decatur St.
Beaty Parlors
 Poro Auburn & Belle St. N. E.
Theaters
 Royal Auburn Ave. N. E.
Ashly Hunter St. N. E.
Dance Halls
Sunset Casino
Service Stations
Halls Auburn Ave. N. E.
COLUMBUS
 Lowes Hotel
(DUBLIN)
TOURIST
 Mrs. H. T. Banyon 316 S. Jefferson
 Mrs. M. Burden, 508 McCall St.
 Mrs. R. Hunter 504 S. Jefferson
 Mrs. M. Kea 405 S. Jefferson St.
(EASTMAN)
TOURIST
 J. P. Cooper 211 College St.
 Mrs. M. Mariano 408 1st Ave.
(GREENSBORO)
TOURIST
 Mrs. C. Brown Caanen Section
 Mrs. E. Jeter Railroad Sec.
 Mrs. B. Walker Springfield Sec.
MACON
 Douglas Hotel—361-3 Broadway
 Richmond Hotel—319 Broadway
(MACON)
TOURIST
 Mrs. M. Clemons 104 Spring St.
 Mrs. E. C. Moore 122 Spring St.
 Mrs. F. W. Henndon 139 1st Aev.
 Mrs. C. A. Monroe 108 Spring St.
SAVANNAH
(TRAILERS PARK)
 Jerry Cox
(WAY CROSS)
TOURIST
 Mrs. E. Duggar 964 Renolds St.
 Mrs. K. G. Scarlett 843 Reynolds

(ILLINOIS)
CHICAGO
HOTELS

Brookmont—3953 S. Michigan Ave.
Claridge—51st & Mhichigan Ave.
Grand—5048 S.Parkway
Huntington—649E 37th.St.
Monogram—3449 S. State St.
Ritz—409 E. Oakwood Blvd.
Southway—6011 S. Park Aae.
Trenier—409 Oakwood Blvd.
Tyson—4259 S. Parkway
Vincennes—601 E. 36th St.
Y. M. C. A.—3763 S. Wabash Ave.
Y. W. C. A.—4559 S. Parkway
Franklin—3942 Indiana Ave.
CENTRALIA

Mrs. E. B. Clayborne
303 N. Pine St.

Barber Shops
 P. Coleman 503 N. Poplar St.
Beauty Shops
 M. Coleman 503 N. Poplar St.
Service Stations
 Langenfield 120 N. Poplar St.
DANVILLE
TOURIST
 Stewart—E. North St.
SPRINGFIELD
HOTELS
 Dudley—130 S. 11th St.

KENTUCKY
LOUISVILLE
HOTELS
 Allen—2516 W. Madison
 Walnut—615 Walnut St.
 Y. W. C. A.—528 S. Walnut St.
MOMMOUTH CAVE
HOTELS
 Brantsford
MT. STERLING
HOTELS
 Dew Drop Inn—E. Locust St.
PADUCAH
 Jefferson—514 S. 8th St.
 Metropolitan—724 Jackson St.
 Washington—805 Washington St.

LOUISIANA
NEW ORLEANS
HOTELS
 Astoria—225 S. Rampart St.
 Chicago—Bienville St.
 Patterson—761 S. Rampart St.
 Page—1038 Dryades
SHREVEPORT
 Lloyd—Milom St.

MAINE
PORTLAND
 The Thomas House—28 "A" St.

MARYLAND
HOTELS
ANNAPOLIS
 Wright's—26 Calvert St.

FIGURE 4.1 Bransford Hotel lodging entry, *Green Book* 1938 edition
Source: Schomburg Center for Research in Black Culture, Manuscripts, Archives and Rare Books Division, The New York Public Library.

2016). The Bransfords are recognized as having over a hundred years of family connection to Mammoth Cave as guides and hotel owners, managers, and employees. Mat Bransford, one of the 1838 group of enslaved cave guides, was the son of a wealthy white man from Tennessee, Thomas Bransford, and an enslaved woman. Mat married an enslaved woman, Parthena, and had four children born into slavery. Their first three children were sold away from the family. After emancipation Mat remained at Mammoth Cave for the rest of his life. His youngest son Henry followed in his footsteps and became a guide at Mammoth Cave. Henry represented the second of five generations of Bransford guides at the cave.

Mat Bransford's grandson Matt, a third-generation cave guide, and his wife Zemmie owned and operated a hotel called the Bransford Resort out of their home following the Civil War. The hotel was listed in the 1938 issue of *The Negro Travelers' Green Book* (see Figure 4.1). Because Blacks were not allowed to be on the same tour as whites, except as guides, Matt led special tours for Black people allowing them to experience the cave as tourists. Matt was an ambassador for Mammoth Cave and championed the experience within the African American community. Matt and Zemmie Bransford eventually lost their business and home to Eminent Domain when the area was taken over by the National Park Service (National Park Service Bransfords Site Bulletin n.d.; National Park Service 2018c; WKU KenCat Online Collections; Ohlson 2006; Lyons 2006; Schmitzer 1995; West 2010).

Louis and Matt, both sons of Henry Bransford, were two of the last Black guides at the park. Matt retired in 1937 and Louis retired in 1939. Although their family had served as cave guides for 100+ years, the Bransford era ended when the National Park Service took control of Mammoth Cave in 1941 and only employed white guides. It was not until 2004 that another Bransford worked as a guide: Jerry Bransford, the great-great grandson of Mat Bransford (the 1838 guide), represents the fifth generation of the family.

It was the NPS that authorized Mammoth Cave as a site of history and heritage. Mammoth Cave became a U.S. National Park in 1941 (it also became a World Heritage Site in 1981). The Bransford family's intergenerational knowledge of caving was key in shaping the spatial and architectural knowledge used to develop Mammoth Cave as a tourist attraction before and after the NPS took over. When the NPS assumed authority over the cave, active exclusion was manifest and dictated park operations. Racial segregation or racial isolation between Blacks and whites was expressed in terms of temporality in at least two ways: first, through the exploitation of Black labor during the time period of slavery and Jim Crow segregation. During enslavement, Blacks labored as miners and acquired familiarity with the caves. They also served as guides, made discoveries, and developed new passages for cave tours. And after slavery ended Blacks continued to serve as guides and became cave tourism entrepreneurs. Then, after over a hundred years of Black laboring history and expertise Mammoth Cave was taken over by the NPS and all Black guides were fired and replaced by whites.

The second way NPS imposed racial segregation/isolation was through a *temporal* process of segregation with respect to tours—mandating tours for Blacks and whites on different days and times. And, from 1941 until after the Civil Rights movement in 1964 Blacks were completely absent as tour guides. This segregation breached longstanding African American intergenerational family connections to the caves. The Bransford family history is a direct reminder of the consequences of active exclusion—the seizing of property of Black families located around Mammoth Cave through Eminent Domain and firing of Black tour guides.

The second imprint of Black identity concerns Black labor. Not only were Blacks tour guides, as evidenced by the familial history of the Bransfords, but Black labor created much of what is defined as the Mammoth Cave National Park site today. It was the Civilian Conservation Corps (CCC) and particularly Black labor that built and transformed Mammoth Cave into a national park site (see Figure 4.2). The CCC was established by Congress under President Franklin D. Roosevelt on March 3, 1933 to provide jobs for young, unemployed men during the Great Depression. They made major contributions to forest management and other conservation projects. Although the CCC was segregated and few places wanted Black men in close proximity to whites, Mammoth Cave was considered safe. Historian Jeanne Cannella Schmitzer writes,

> The Civilian Conservation Corps followed the normative pattern of segregated military personnel—white officers and technical staff supervising Black

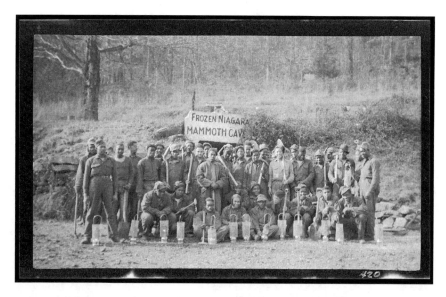

FIGURE 4.2 African American enrollees cave crew, CCC unit, Mammoth Cave National Park, circa 1935
Source: Mammoth Cave National Park. http://purl.clemson.edu/F7726120EAD19993 0FD82A8F098CE7AD.

enrollees in segregated camps. Even with white camp commanders, many communities opposed the placement of Black camps in their vicinity. The areas contended that the presence to a large number of Negro males would pose a threat to local white females. As a result, many Blacks were assigned to wilderness areas such as state and national parks. Mammoth Cave, Kentucky, was considered a perfect location for Black enrollees because it would require an enormous amount of labor to transform the expanse into a national park—and because it was remotely located.

(Schmitzer 1995, 449)

Schmitzer's observations underscore that Mammoth Cave was not only a site that could be developed into a National Park. It was also a site in which active exclusion via the apparatus of architecture was articulated as part of the structuring and placement of labor and laborers in relation to whites in building the site. The CCC is an example of the labor that was used to develop the caves in the 1930s. And it also shows the institutionalization of active exclusion through the U.S. government and its willingness to go along with fear about Black male presence in society and in locations in close proximity to whites, particularly white women, a fear responsible for sending them to remote and often rural communities in places like western Kentucky in the first place. Not only does this example highlight how Black labor was used to develop the built environment of a National Park, it also shows how Black labor must be seen in the context of white fear.

Yet this is not the only story. The imprint of Black identity is situated throughout Mammoth Cave and in memories and stories of those who visited the caves. Black people worked in saltpeter mining and later as cave tour guides and hotel owners. And they lived and worked in nearby places like Bowling Green.

Visiting Shake Rag: A Safe place for Black Travelers

During the course of my stay at WKU I inquired about places in Bowling Green, located about thirty-five miles northeast of Mammoth Cave, listed in the *Green Book*. As previously mentioned, Green's goal in publishing the *Green Book* was to identify safe spaces for African American travelers. The Hotel Southern Queen on State Street near Highway 31-W was just such a place. For example, both the Hotel Southern Queen and Nancy's Tea Room are listed in the *Green Book* 1948–1964. They are located in the Shake Rag community.[3] The Southern Queen, built in 1906, still stands today and is under private ownership (Figure 4.3) within the same family, although it is no longer used as a hotel. When I visited the site, there was no marker indicating that it was ever listed in the *Green Book* as a safe place to enjoy leisure for African Americans.

By way of comparison, Bowling Green is known as the birthplace and home of Duncan Hines, of packaged cake mix fame. Hines, a white male, worked as traveling salesman for over thirty years, authored travel guides, and marketed cookbooks and kitchen products (Hatchett and Stern 2014; Hines 1947).[4] It is revealing

to compare his restaurant and travel guide books (for example, *Lodging for the Night*, published annually 1938–1962) to the *Green Book*. Hines' work reflects an unmarked focus on white space, a process of invisible *partitioning*, in which race is not directly mentioned but rather there is an understood boundary demarcating white-only access. Invisible partitioning facilitated movement in places and within structures where Black travelers were not welcome. Thus, his leisure recommendations indirectly supported segregation based on processes of fixed, malleable, and behavioral separation of Black and white Americans (Weyeneth 2005, 22–23).

The Shake Rag community was designed and constructed at a specific point in time, a critical moment in history, to circumvent the realities of segregation. This community exemplifies, as did American Beach in Florida, how the construction of alternative spaces in the face of segregation was a form of resistance to racial isolation. Weyeneth describes this as imaginative reaction to segregation created to resist imposed architectures of segregation (2005, 33). And like the process of duplication, which was a method of achieving segregation, development of alternative

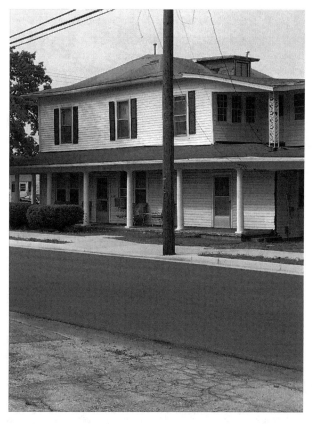

FIGURE 4.3 Hotel Southern Queen building, May 2017
Source: Photo by author.

spaces resulted in the establishment of separate facilities and places for African Americans—which in many cases duplicated or existed alongside spaces designated as white only.

Unexpected finds like the Hotel Southern Queen offer tangible reminders of the challenges faced by African Americans travelers during the Jim Crow period of American history. More importantly, they are a testament to African American travel ambitions and agency in the face of exclusion. They respond to the question, "Am I welcome here?" and, in ways that importantly deviate from the world of travel known to Duncan Hines and his readers, showcase the *how* and the *what* of African American travel and leisure.

The story of Black cave guides and tourism at Mammoth Cave and the story of Shake Rag as a haven for Black recreation and leisure has implications for today. As unexpected sites of leisure, Mammoth Cave and Shake Rag help inform and expand national imaginations. In this discussion such places show the importance of critically representing the relationship between African Americans and the great outdoors (see Finney 2014). These places and their stories serve to both critique and expand U.S. national narratives, providing new insights into leisure, race, and tourism.

In thinking about Mammoth Cave in the context of the underrepresentation of non-white visitors to national parks, this chapter has sought to show why it is problematic to simply ask why African Americans are underrepresented at outdoor sites of recreation like national parks. The discrimination and/or marginalization hypotheses offer limited explanations for explaining the reality of decisions and actions, through apparatuses such as architecture, resulting in "active exclusion." I have found it to be more insightful to focus on specific cases, specific communities, and specific experiences, and to ask how their knowledge and how their experiences contribute to the ways in which sites are interpreted and leisure is imagined.

This chapter has shown that narratives of leisure and race should be reexamined to include a more comprehensive analysis of sites such as Mammoth Cave and Shake Rag. Specifically, my analysis brings into critical relief the ways in which segregation operated at a national park site. For example, it shows that the NPS strategy for the site focused on taking deliberate action to block African American associations with the park after its acquisition. NPS fired African American cave guides, including families with long histories of cave knowledge, in favor of white guides (see also Algeo 2013). NPS also established segregated lodging and eating spaces on park grounds. Arguably, in the case of Mammoth Cave, Blacks did not simply "experience" segregation and become disenfranchised. They were deliberately blocked from association with caving as tour guides and limited as patrons by NPS. Although the NPS now promotes the role and expertise of Black people as cave guides, it underrepresents its institutional role in the disenfranchisement of an entire group of people.

In her book *Black Faces, White Spaces*, Carolyn Finney (2014) examines the relationship between African Americans and the great outdoors from the perspective of public representation and imagery. She asserts that a denial of the basic

humanity of African Americans exists in their very absence from public imagery showing outdoor activities and engagement with nature. This absence has perpetuated a cultural divide in which Black people are stigmatized and placed outside of what is considered the norm with respect to outdoor leisure pursuits.

Mammoth Cave makes visible active exclusion and the complexities of the architecture of race, racial isolation and leisure. It also reveals the degree of engagement that Blacks had with outdoor leisure activities and the kind of expertise they possessed around caving in Kentucky as guides, explorers, entrepreneurs, and as leaders in sustaining caving tourism. Lastly, Shake Rag exemplifies the role of Black entrepreneurship—such as owning and managing hotels and eating establishments that were spaces of welcome catering to Black and white visitors.

Notes

1 Research conducted at Mammoth Cave was part of a National Park Service contract—task agreement number P15AC01773 and Cooperative Agreement number P13AC00443 for an Ethnographic Overview and Assessment of Mammoth Cave National Park and Knob Creek Abraham Lincoln Boyhood Home from 2015 to 2017.

2 The period from approximately 1816 until the 1930s was a time of the private ownership of Mammoth Cave as numerous tracts of land outside the Estate were purchased by families and developed as farmland. It is estimated that over 500 families settled north and south of the Green River in the area surrounding the Mammoth Cave Estate—many were African Americans and descendants of enslaved Africans that had worked in the saltpeter mines and caves. Several of the settlements resulted in the establishment of small farming communities. As part of these communities, schools and churches were established. Nearly a hundred cemeteries were established, with anything from one or two interments to several hundred burials.

3 The Shake Rag Community was developed after the Civil War along the north end of State Street in Bowling Green and considered a haven for those living in or traveling through segregated Bowling Green prior to 1964. A local Shake Rag Preservation group distributes a brochure entitled *Like a Family: Life on North State Street Traveling Exhibit and Walking Tour*. Also, the Bowling Green Area Convention and Visitors Center maintains an online Shake Rag Walking Tour brochure. See www.visitbgky.com/shakerag/. Accessed December 14, 2018.

 The Hotel Southern Queen is listed in the *Green Book* in 1948–1953; 1956/57; 1959–1964. Although the building was still standing in the same location listed in the guide book (State Street, Hwy. 31-w), as of May 2017, there was no marker indicating its status in African American travel and leisure history. Nancy's Tea Room (415 3rd St) is listed in the *Green Book* in 1953–1957; 1959–1961. The building is no longer standing and there is no marker indicating its location and history in terms of the *Green Book*.

4 Duncan Hines (1880–1959) was born and raised in Bowling Green, Kentucky. He was a traveling salesman for over 30 years and took extensive notes about good places to eat and lodge. He became famous for his recommendations, seal of approval, cookbooks and travel guides. Hines became a millionaire when he and entrepreneur Roy H. Parks put the Hines-Park name/logo on an array of kitchen products. Eventually the Duncan Hines brand name was sold to Procter & Gamble. Duncan Hines published *Adventures in Good Eating* series 1936–1962—see the 1945 edition online with University of Michigan and the 1959 edition online with University of Wisconsin-Madison. He also published a few other guides such as *Lodging for a Night* (1938); *Duncan Hines Vacation Guide* (1948).

5

EXCEEDING SEGREGATION LIMITS

Welcome to the Marsalis Mansion Motel in New Orleans

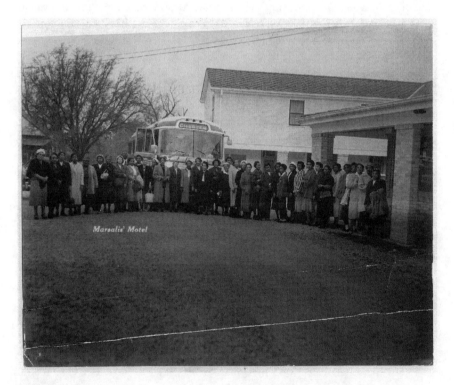

FIGURE 5.1 Large group standing outside a charter bus at Marsalis' Motel (n.d.)
Source: Ellis L. Marsalis Sr. papers, Amistad Research Center, New Orleans, Louisiana.

The Marsalis Mansion Motel in New Orleans exceeded the limits of segregation. It was conceived with this goal in mind. The late Ellis Marsalis Sr., patriarch of the famed music-making family, set out to create a safe place for African American leaders, entertainers, and other travelers who were refused lodging in downtown hotels in New Orleans during Jim Crow. He not only created a safe place, he created a special place—a landmark in New Orleans for African Americans.

The motel's existence is representative of why norms that equate leisure with whiteness must be unpacked. The story of the motel illuminates African American travel and leisure and the complexities of traveling while Black and navigating spaces designated as white-only. This situation is often overlooked in dominant narratives of leisure scholarship that center on white experiences that are unburdened by the strategic knowledges Blacks used to circumvent segregation and its consequences. Segregation seeks to contain and control. It makes those excluded from white-designated venues believe that it is they who are deficient in some way, lacking in some way.

Ellis Marsalis Sr. responded to the needs that arose from segregation by establishing something big, something different, and by many accounts, something elegant. The Marsalis Mansion Motel was a venue for musical entertainment primarily serving African Americans travelers. It also offered lodging, dining, swimming, and space to host meetings to these same travelers.

The story of the motel is part of a larger narrative of Black leisure. Ellis Sr. and his family are linked to the lives of the motel's guests and to the experiences of Black travelers and the history of Black businesses across the U.S. For instance, the Mary Elizabeth Hotel in the Overtown neighborhood of Miami Florida, built in 1921, offered lodging to African Americans denied accommodations at white-only Miami Beach hotels during Jim Crow. Jackie Robinson, Thurgood Marshall, W. E. B. Du Bois, and Count Basie were notable guests. It was closed after desegregation and eventually demolished. In Los Angeles, the Dunbar Hotel, formerly named the Somerville Hotel, was the heart of African American culture in that area. Built in 1928, it offered first-rate lodging to Blacks denied lodging at white-only establishments. Notable visitors included Louis Armstrong, W. E. B. Du Bois, Billie Holiday and Duke Ellington, Now listed on the National Register of Historic Places, the Dunbar Hotel currently serves as low-income housing.

Anthropologist Iris Carter Ford points out the import of focusing on Black travel experiences as part of a group story: a powerful testament of resistance against an oppressive system and a means of filling in the gaps in American history by including the lives of African Americans. She writes:

> Thus personal voice becomes mass voice, tied intimately with political movement. Relating life stories, then, becomes a political act, not in any hegemonic sense, but simply in the act of analyzing the internally conflicting interrelationships among a people in a society.

(Ford 2001, 37)

The Marsalis Mansion Motel is a complex whole made up of smaller parts that, when analyzed collectively, can narrow our attention to a singular challenge—the challenge of showing the systemic burden and ensuing consequences of racial segregation on African Americans as a conscious act, manifest in leisure. It represents part of the biography of segregation.

Active Exclusion and Repressive Laws

Active exclusion, as discussed in chapter 1, builds on notions of social exclusion (Barry 2002; Silver 2007) and highlights the ways in which people, communities, and institutions marginalized, excluded, and denied access and rights of full participation in society as equal citizens to Blacks and non-white "others." It operates through many domains and apparatuses as discussed throughout this book. In this chapter I examine how active exclusion was activated through the law and legal statutes aimed at restricting and disenfranchising African Americans, focusing on the exemplary instance of the Marsalis Mansion Motel.

As suggested, viewing the Marsalis Mansion Motel through the framework of active exclusion offers a partial biography of segregation in Louisiana. It sheds light on the legal and social environment as well as on the people who frequented the Motel, worked in the Motel, and continue to honor the memory of Ellis Sr. My analysis also emphasizes what Ellis Marsalis Sr. did to resist the limits of segregation, given that his establishment operated under the most repressive segregation laws in the U.S.

The law is often overlooked as a means of controlling space and maintaining white-only communities, subdivisions, and places of recreation. Richard Rothstein's book *The Color of Law: A Forgotten History of How Our Government Segregated America* (2017) argues that racial segregation today is predicated not only on private and individual choices (*de facto*), but also, and more significantly, on a legacy of government-sponsored discriminatory policy embedded in law. He maintains that the truth of *de jure* segregation (codes, statutes, ordinances, laws, and legal mandates) has been downplayed in contemporary discussions of segregation (Rothstein 2017, 95).

Rothstein focuses on the direct role that both *de jure* and *de facto* segregation played in sustaining racial isolation with legal backing. He highlights two major programs implemented by the federal government—the Public Works Administration and the Federal Housing Administration (FHA), which was established in 1934, one year after the Public Works Administration. At the time of its inception the FHA would not insure mortgages for African Americans. However, what was more disenfranchising was the fact that the FHA subsidized builders who developed and mass-produced suburban home tracts and entire subdivisions with the stipulation that in order to obtain financing they could not sell homes to African-Americans. Covenants restricted or prohibited white homeowners, who had originally purchased FHA financed homes, from selling or reselling to African Americans. The government funded GI-Bill program, which had been developed specifically

to provide home-buyer and education benefits for WWII veterans, adopted all of the FHA agency's racial exclusion clauses and practices. The courts upheld the unconstitutional disenfranchisement of Blacks by the FHA, essentially allowing the agency to deny loans and sanction restrictive homeowner covenants. It was only after a Supreme Court ruling in 1948 that a 1926 decision supporting restrictive racial covenants was reversed (Rothstein 2017).

The story of the Marsalis Mansion Motel is situated within the context of the history of segregation in Louisiana, but must be understood with this broader federal history of legal active exclusion. Following the Civil War and during Reconstruction (1866–1877), the state of Louisiana implemented some of the most restrictive measures aimed at curtailing earlier gains at the federal level (Brown 2010). The promise of Reconstruction, in other words, was not realized. Specifically, the rights and protections of the Thirteenth, Fourteenth, and Fifteenth Amendments to the U.S. Constitution, which were meant to include the abolishment of slavery and the recognition of citizenship for African Americans and guarantee the right to vote for African American men, were undermined and negated by whites who were determined to insure white supremacy. This played out most notably in the legal realm (Alexander 2010; Baker 1998; Brown 2010; Chafe 2001; Kendi 2016). It was through the apparatus of the law that active exclusion was solidified.

In 1865, Louisiana began implementing laws known as "Black codes" which had first been used to regulate Blacks during slavery. These laws essentially formed the basis of racial segregation practices, or Jim Crow, which placed whites on top of the social order and limited Black movement and access to basic citizenship rights. In Louisiana this played out in many ways. For example, in 1891, the legislature segregated the railroads within the state such that Blacks and whites were forced to occupy separate areas in rail cars. This decision was upheld at the federal level in 1896 with the U.S. Supreme Court decision on *Plessy vs. Ferguson* case. In this case, Justice Henry Brown stated that segregation did not deprive Blacks of their rights and that Homer Plessy, the African American who sued the railroad company in Louisiana, was not deemed an inferior person by virtue of whites and Blacks occupying separate spaces. Essentially, the U.S. Supreme Court ruled that states could establish "separate but equal" facilities, thereby legally affirming and instituting segregation in the U.S. (Brown 2010).

Following the Plessy decision, everything that could be segregated in Louisiana was segregated. Blacks were stripped of the right to register to vote; street cars in New Orleans were segregated; cohabitation between Blacks and whites (i.e. marriage or in domestic situations) was prohibited; jails were segregated; the Catholic Church established a segregated parish in New Orleans; and Blacks were only allowed to be in certain places at specific times such as before sundown (Brown 2010; Reed 1965).

This rush toward segregation extended to leisure activities, businesses, and institutions, as the needs of white visitors and patrons were accommodated at the expense of African American who, although they were citizens of the U.S., were

denied the right to travel where they wanted or participate in tourism and recreation activities at sites open to the public. The need to protect white-only spaces was prioritized and sanctioned by law.

Cultural anthropologist Lee D. Baker's book *From Savage to Negro* (1998) looks at the influence of anthropology on the construction of race and implications with respect to racial segregation policies and the racial isolation laws derived from *Plessy v Ferguson* to *Brown v the Board of Education* federal cases. I follow his approach while also cataloguing other racial isolation laws within the same period, some of which relate to leisure activities. For instance, I attend to how Black rights were undermined by statutes and state codes such as the 1921 Housing Statute that "Prohibited Negro and white families from living in the same dwelling place"; the 1932 Residential State Code which stated that "No person or corporation shall rent an apartment in an apartment house or other like structure to a person who is not of the same race as the other occupants"; the 1956 Recreation Statute which mandated that "Firms were prohibited from permitting on their premises any dancing, social functions, entertainments, athletic training, games, sports or contests in which the participants are members of the white and Negro races"; and the 1956 Employment Statute which

> Provided that all persons, firms or corporations create separate bathroom facilities for members of the white and Negro races employed by them or permitted to come upon their premises. In addition, separate eating places in separate rooms as well as separate eating and drinking utensils were to be provided for members of the white and Negro races. Penalty: Misdemeanor, $100 to $1,000, 60 days to one year imprisonment.

Additionally, the 1956 Public Accommodations Statute which stated that "All public parks, recreation centers, playgrounds, etc. would be segregated"; and finally, the 1960 Voting Rights statute that "Required that the race of all candidates named on ballots be designated" (see Study the Past—Jim Crow Laws: Louisiana).

The 1964 Civil Rights Act reinstated or upheld rights of citizenship previously denied African Americans by statutes and codes enacted at state levels. As the Civil Right movement gained traction, lynching as a form of social control rose in Louisiana. Efforts by organizations focused on countering segregation policies also increased. The NAACP (National Association for the Advancement of Colored People), for example, became increasingly active in resisting efforts to maintain a system of white supremacy and deny Black citizenship rights (Brown 2010). Many Black business people worked alongside, supported, and drew support from organizations as the NAACP. Marsalis and other Black hotel owners across the country essentially did not accept the limited notions of race underlying these legal statutes. Nor did they concede to the circumscribed ideas about the place of Black people in society. Ellis Marsalis Sr. was among those who did not accept white supremacy, which was embedded in Louisiana law, did not inhibit his ambitions, and instead entered the hospitality business and established a motel. In fact, it was precisely the

context of white supremacy that served as his motivation to do so, which indicates the determined role African American entrepreneurs took in opposing active exclusion.

Ellis Marsalis Sr. and the Marsalis Mansion Motel

I first learned of the motel and its connection with the Marsalis family from a friend and former colleague, Daryl Thompson. During one of our conversations, I mentioned that I was working on a book on segregation-era African American travel and leisure. I explained that there were so many stories that had not been shared and that I was fascinated by the *Green Book* travel guide. Suddenly, Daryl remembered the dedication ceremony in New Orleans he had attended a year earlier for his uncle—Ellis Marsalis Sr. (1908–2004).[1] Apparently, being the patriarch of a talented musical family was not Ellis Marsalis' sole legacy.

Ellis Sr. was a man with wide-ranging interests. He had married Florence Robertson and they had two children—Ellis Marsalis Jr. and Yvette Marsalis Washington. Their son, Ellis Marsalis Jr., and grandchildren, Branford, Wynton, Delfeayo, and Jason Marsalis, are acclaimed musicians known around the world for their extensive contributions to jazz. Ellis Sr., though, was known as a successful businessman and political leader. He was active in the Republican party and in addition to owning the motel he was one of the first African Americans to own an Esso gas station franchise in the state of Louisiana. In these roles he received many accolades and awards from community and national organizations. For example, he was president of the Nationwide Hotel Association and he founded a Booster Club to help register countless African American voters throughout New Orleans regardless of party affiliation. The Ellis Marsalis Sr. family were active in St. James A.M.E. Church and members of the Dryades Street YMCA in New Orleans. Ellis Sr. was also a member of the Ancient and Accepted Scottish Rite of Freemasonry (Galatowitsch 2011).

For Ellis Sr., what began as a simple act of offering a space for Black persons and organizations to host meetings grew into something larger. I interviewed Yvette Marsalis Washington and Ellis Jr. and accessed the Ellis Marsalis Sr. papers housed in the Amistad Library at Tulane University in New Orleans. These papers, the *Green Book*, and my conversations with Daryl, Yvette, and Ellis Jr. provide insight into Black leisure and Black spaces of organizing, excellence, and perseverance in the era of segregation.

Making a Way: Developing a Nationally Known Motel

A shrewd businessman, Ellis Marsalis Sr. purchased land in the Shrewsbury community of Jefferson Parish and converted a chicken barn into a nationally known motel. The Marsalis Mansion Motel, built in 1943, was opened to the public in 1944. It was known by a variety of names—including Marsalis' Motel, Marsalis

Mansion, and Marsalis Tourist Home. It eventually boasted over forty rooms, a swimming pool, and honeymoon suites. In the 1950s, the motel was home to a popular but short-lived nightclub called the Music Haven, which was operated by Ellis Marsalis Jr. (Quinlan 2014). Prominent hotel guests included Rev. Dr. Martin Luther King, Congressman Adam Clayton Powell Jr., Thurgood Marshall, Ray Charles, Dinah Washington, Nat King Cole, and Ike and Tina Turner. The motel closed in 1986. Eventually the family sold the motel and land, and the building was demolished.

Ellis Marsalis Sr. and his business associations are listed in four different issues of the *Green Book*, starting with the 1947 issue in which the Esso Service Station he owned is featured along with his motel, then called the Riverside Tourist Court Lodge. The 1947 entries read: (a) "*Bill Board Esso Service* at 2900 S. Claiborne Ave. New Orleans—E. L. Marsalis and J. L. Wicker;" and (b) "E. L. Marsalis, Sr. Prop.—*Riverside Tourist Court* lodging at 3501 Riverside Drive— Jefferson Parish, New Orleans." In the 1957 issue of the *Green Book*, the Marsalis' Motel is advertised as "Something New in New Orleans" and located at 110 Shrewsbury Road, New Orleans, as seen in figure 5.2 (Green 1957, 25). The Marsalis Motel at 110 Shrewsbury Road is also listed in the 1959 and 1960 issue of the *Green Book*.

Surveying the terrain of segregation geographically in New Orleans and focusing on places that existed that welcomed Black clientele is informative. These places have often been ignored or marginalized in mainstream literature on travel and leisure or in public memory regarding what once existed during Jim Crow. From 1944 to 1986, the Marsalis Motel was one of only a few establishments to offer lodging to African Americans visiting the New Orleans area. The Green Book helps highlight how racial isolation patterns played out geographically in New Orleans in the context to the Marsalis Motel and other surrounding establishments.[2]

Born in 1936, Yvette Washington (the daughter of Ellis Marsalis Sr.) was unaware of the *Green Book* or the motel's listing in it. She did not know whether her father knew of it, either (although I am certain he did because of Esso's relationship to the *Green Book*). However, she was highly engaged when discussing her memories of the motel and her eventual role as manager. Yvette recalled that she often clashed with her father over management decisions; she considered the fact that she was his daughter and a woman to be the main reason for some of the disagreements. But she was proud of what he set out to do.

She said that when he acquired the property it was located in "the country." It was basically one farm among many. She said they raised cows and chickens and pigs and had lots of fruit trees. There was also a barn on the property. Eventually people began asking her father if they could use the barn for meetings. Finally, he agreed. Then people wanted a place to stay and he decided to expand upon the barn to create the motel. In this excerpt from my interview with Yvette, who operated the motel for 31 years, she tells me about people who visited the motel for meetings and lodging:

And when the people would come to town to have their meetings or whatever they're coming for, they could go up there and hold their meetings.

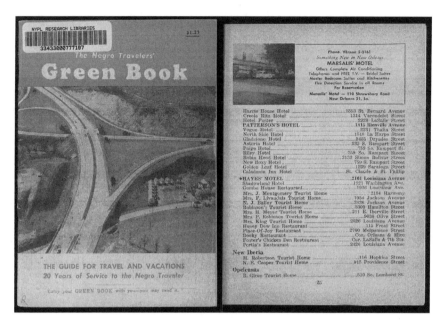

FIGURE 5.2 Green Book, 1957 cover and listing of Marsalis Motel
Source: Schomburg Center for Research in Black Culture, Manuscripts, Archives and
Rare Books Division, New York Public Library.

> Well this is where Dr. King came and Thurgood Marshall and that's when
> these people were coming to town and they would come and hold their
> meetings on the property. So, from there somebody else suggested to him well
> why don't you, you know, you should divide up the things and make some
> rooms and rent out some rooms. And that's how the motel started, a couple of
> rooms at a time. And he just added on to the barn.
>
> *(Washington 2016)*

Yvette's stories provide a first-hand view of what the motel looked like and why
it was considered a great place to stay. They also support the claim by the *Green
Book* that the motel was one of the few places in the New Orleans area to offer
luxury accommodation to Black travelers. Lodging, recreational, and entertainment
options at the Marsalis Mansion Motel were offered to Blacks in New Orleans at
the same time that the 1956 Louisiana Public Accommodations, Recreational, and
Employment statues dictated complete separation between Blacks and whites.
Yvette said of the motel,

> We had a swimming pool, a covered … fiberglass-covered swimming pool
> that … . He went all the way with this thing. We had a lounge and, it was
> really nice. Also, there was a library at the restaurant, and there was a bar.
>
> *(Washington 2016)*

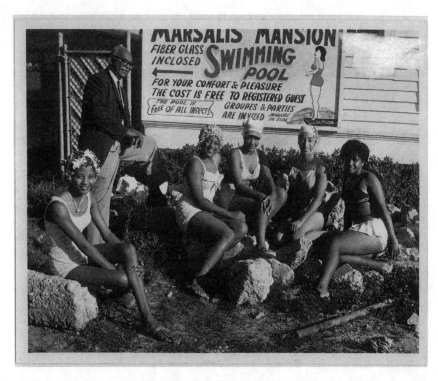

FIGURE 5.3 Ellis Marsalis Sr. standing next to group of five women in bathing suits and swim caps by a sign for the swimming pool at the motel (n.d.)
Source: Ellis L. Marsalis Sr. papers, Amistad Research Center, New Orleans, Louisiana.

It was clear throughout the interview that Yvette loved working in the motel and admired her father for what he accomplished despite many obstacles faced as a Black businessman in the South. She also underscored what was like to be a female manager of a motel during that time—yet another side of leisure to be explored in further detail. Her authority and knowledge was constantly challenged by suppliers, contractors, and even, as suggested, her father. Yvette told me that she did everything in the hotel from cleaning to registering guests to buying supplies to marketing to keeping the books to making sure guest concerns were addressed. She eventually handled all the day-to-day operations of the motel and met with her father only to keep him informed. Yvette recalled that it was a job with tremendous responsibilities, but one she was good at and enjoyed.

But Ellis Sr. himself owned and operated his hotel with some risk. In an interview conducted in 1988 by Dr. Lawrence Powell, Ellis Sr. described how he came to own the land where what became the Marsalis Mansion Motel was built. He also discussed what it meant for a Black man to own such land in Jefferson Parish, recalling in particular a time when some white students and faculty from Mississippi State came to town to attend a meeting with the Urban League, a predominantly

Black group, when "segregation fights were so bad." Ellis Sr. was approached by representatives from the Urban League and asked if they could hold their meeting at the motel. He told them yes, but reminded them that he had some problems because some people in the area resented that he owned the motel and that African Americans could use it. He recalled:

> I told them yes, you could meet in my place as long as you don't have a lot of pictures taken outside, cause I ran into some problems. I had some resentment there.
>
> The man that sold me the place, he was visited by some of the teachers from the school and the priest up there, and they wanted to know from him, 'why did you sell that house to the [n-word]?' It used to be the judge's house.
>
> (Marsalis Sr. 1998)

In short, he was met with resentment and opposition. However, he still exceeded the limits of segregation by creating a motel and gathering space that proved to be both a site of recreation and leisure and a place of import for hosting important meetings and events during the Civil Rights era.

Commemorating a Motel Founded on the Other Side of the Color Line

The motel closed in 1986. And in 1993 the building was condemned and then demolished. But what is remarkable about the Marsalis Motel today is the historical plaque that now marks the spot where the motel once stood. Typically, in the construction of public memory, roadside markers and associated historical narratives revolve around or center on the lives and history of white Americans, particularly white males. There are only a limited number of markers recognizing the history and experiences of African Americans in public spaces (Levin 2017). This particular case is remarkable because it recognizes the life and accomplishments of a Black man who persevered during an era when laws and customs were aimed at denying rights to African Americans.

On January 9, 2015, the site of the former motel was commemorated during a public ceremony. Among those in attendance were members of the Marsalis family, including Ellis Marsalis Jr. and his sister Yvette Marsalis Washington (see Figure 5.4). Additionally, public officials and representatives from the Jefferson Parish Historical Commission were in attendance. According to newspaper accounts of the event, it was a great success and brought back memories for many who had once known the site (Parker 2015; Quinlan 2014). As part of the ceremony a Louisiana Highway Marker was placed along River Road close to where the motel once stood, near the intersection of River Road and Shrewsbury Road in Jefferson Parish.

The plaque is a reminder of one family's history and the reality of segregation in America. Like the Hotel Southern Queen in Bowling Green, the Marsalis Mansion

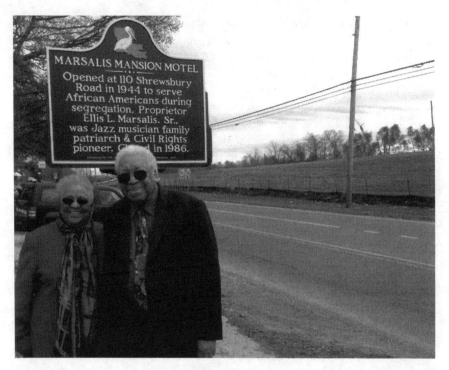

FIGURE 5.4 Yvette with her brother Ellis Marsalis Jr. at the dedication ceremony and site of the former Marsalis Mansion Motel

Source: Photo courtesy of Daryl Thompson.

Motel served several functions for its community that are important testimony to the ways in which African Americans constructed alternative spaces to support and care for one another as a response to segregation (Weyeneth 2005, 34).

Locating the Marsalis Motel Today

I visited the site of the former motel in May 2017 and reflected on the role this now empty lot played in the life of so many travelers. The location is easy to miss because it is situated on a busy section of River Road (at the Shrewsbury Road intersection), right before the Huey P. Long bridge over the Mississippi River. There is constant traffic. The levee stands just across from the site of the old motel; its high, imposing walls remind you of the power of the Mississippi River and what is being kept back. There is a restaurant at the opposite corner of the lot, River-shack Tavern, which seemed very popular. However, most customers ignored me as I walked around the lot taking notes and pictures of the marker. Cars whizzed by and people ate and drank on the outdoor patio of the restaurant. No one asked me anything and there seemed to be no one with whom I could speak about the lot. I took my pictures, circled around the block a few times in my car, and left determined to find out more. At the time of my visit I did not realize that the sign

which originally hung on the outside of the Marsalis Mansion Motel now hangs in the Rivershack Tavern. According to newspaper stories, it had been acquired by the previous owner of the restaurant at the time the motel was demolished as a souvenir and reminder of his acquaintance with Ellis Marsalis Sr., who continued to live in the grounds of the former motel until his death in 2004.

The tension associated even with the acquisition of land for his home and then the eventual establishment of a motel for African Americans is articulated clearly in Ellis Marsalis Sr.'s oral history when he describes his land purchase and its meaning. Marsalis Sr.'s experience may be further contextualized by legal practices that operated at the time. As mentioned earlier, homeowner covenants as well as social norms of the time prohibited the sale of property by whites to African Americans (Rothstein 2017). And other statues, such as the 1956 Recreation Statute in Louisiana, prohibited Blacks and whites from participating together in social functions (i.e. meetings and other gatherings) on the same premises.

However, newspaper accounts of the motel appearing in 2015 and 2018 issues of *NOLA.com* are particularly descriptive of contemporary realities concerning the site. These articles situate Ellis Sr. as patriarch of a large musical family and former owner of a prominent motel, who spent his final years living in the grounds of his former motel, which family members have described as in need of significant repair. The physical erasure of this site of leisure that served Black patrons during segregation due to financial distress, lack of maintenance, and replacement by another structure is unfortunately the contemporary story of many sites listed in the *Green Book*.

Family members shared that Ellis Sr. was saddened by the decline in business after desegregation as he had anticipated that the community would continue to support him. A September 27, 2018 article reports that the site of the former Marsalis Mansion Motel was purchased by a developer who plans to establish a 18,000-square foot dog center as well as lease space to a nearby veterinary hospital (Valenti 2018). These accounts of the Marsalis Mansion Motel provide another lens through which one may view U.S. history and underscore what has been lost and gained with desegregation. The story of the motel highlights the importance of preserving public memories through both tangible markers such as plaques and physical structures and intangible cultural artifacts such as oral histories and stories about segregation. It also underscores the import of sharing the *what* of the pursuit of leisure by African Americans in the face of segregation and active exclusion and the *how* of the apparatus of the law and especially legal statutes that must be continually revisited and directly named.

This chapter is an example of how to think in more intentional and nuanced ways about segregation in the present by using a specific example—the Marsalis Mansion Motel in New Orleans. By establishing a motel in the Jim Crow South, Ellis Marsalis Sr. provides an example of exceeding the limits of segregation by creating a space that served the needs of his community. This discussion makes his story, and many others like it, visible within the broader discussion of leisure studies and African American travel and leisure in this book. Segregation aims to limit

the sphere of operation for those deemed inferior. In the case of racial segregation in the U.S., the goal was to maintain a system of white superiority by relegating Blacks and other non-white people to second-class citizenship. In a segregated society, the boundaries of white-only spaces are heavily policed by law and social dictate. Ellis Marsalis Sr., a Black man, did not adhere to dictates of the segregated South during the era of Jim Crow. Instead he built something that was open to everyone. He provided meeting spaces and luxury lodging for African Americans and those on the other side of the color line.

Notes

1 Casual conversations between the author and Daryl Thompson took place January 1, 2015–August 6, 2019.
 During these conversations Daryl shared that he had attended a dedication ceremony held on January 9, 2015 at the site of the former Marsalis Motel. It was held to commemorate his uncle, Ellis Marsalis Sr. Daryl expressed his happiness with getting to witness such an important event in his family's history and in African American history. Later he put me in contact with his cousins, Yvette and Ellis Jr., the surviving children of Ellis Marsalis Sr., and later I interviewed each of them for this book.
2 Daryl Thompson has also produced a map that vividly shows how the geography of segregation played out in terms of the Marsalis Motel and surrounding establishments. Daryl's map marks 1957 *Green Book* lodgings in New Orleans shown in relation to Marsalis Mansion Motel and several white-only establishments located within Jefferson and Orleans parishes (and all within 10 miles of one another). It is anticipated that this map will be located in an online supplemental figures file area to be developed in association with this book.

6

CREATING LEISURE ON FIVE STREETS AND THE RIVER

Tampa, Florida's Spring Hill Community

Located about five miles north of the city of Tampa, Florida, Spring Hill in Hillsborough County consists of just five blocks, and is often concealed within the larger neighborhood of Sulphur Springs.[1] Spring Hill is a historically African American community which formed its own haven against segregation, even as some of its residents labored in jobs which supported the bustling tourist industry that dominated places like Sulphur Springs in Tampa. Residents of Spring Hill comprised the workforce for recreation and leisure businesses that helped define Sulphur Springs as a destination spot for tourists in the 1920s, 1930s, and 1940s. Though the multitude of recreational options available for white citizens were off-limits to African Americans, residents of Spring Hill created places of leisure along the Hillsborough River and at local churches and other venues for their families.

Active Exclusion Through a Lens of Geography

What is apparent when looking at leisure in the context of Spring Hill are the ways in which people sought to exert control over the spatial dictates of segregation and thereby resist the constraints of racial discrimination. These negotiations, which were aimed at circumventing racial norms, laws, and punitive measures, can best be understood through the organizing apparatus of geography and specifically through a lens of racial geography.

Drawing from scholars such as Edward W. Soja (2010), Katherine McKittrick (2006), and George Lipsitz (2011), racial geography is a way to critically think about leisure and race in the context Spring Hill. Each of these scholars, from their disciplinary locations, offer ways of thinking about space and its political and ideological orientation. They articulate creative responses and refusals to adhere to arbitrary assumptions and stereotypes about Black engagements with space. In

addition, they address the imprint that Black people have had and continue to exert on places they inhabit, which in this discussion is applied to leisure.

In many ways, Spring Hill is the story of the segregated South. It is a typical southern African American community, particularly in terms of the legal and cultural enforcement of segregation laws along racial lines that delineated space and placement of Black communities associated with but located outside surrounding white communities. Communities such as Spring Hill in Tampa, Shake Rag in Bowling Green, Kentucky (discussed in chapter 3), and countless others were safe havens for African Americans seeking recreation and leisure, places of worship, movies, restaurants, or other services. These communities offered a welcoming place for Black people excluded from white-only establishments or relegated to using the back door or other segregated entrances.

The practice of racial segregation permeated and dictated social interaction within the community of Sulphur Springs and throughout the city of Tampa. The effects of policies that upheld segregation are reflected in the stories people tell when they remember Spring Hill and Sulphur Springs. Histories of African American communities are continually silenced or unaccounted for in the public record (Jackson 2010; McKittrick 2006, 94). Today, for example, silences still prevail around the history and cultural activities of African Americans and others who lived and worked in the neighborhood of Spring Hill. In particular, the significance of Black churches as sites of resistance and leisure is underrepresented and is introduced here through community stories and records, oral histories, and interviews. Looking at fellowship practices (the ways people gather socially, share, and support one another), particularly in the case of African American church groups, provides critical insight into *what* African Americans were doing in terms of leisure. Centering Black churches affords a view into *how* African Americans resisted white supremacy, an ideology of Black inferiority, as an act of cultural preservation within spaces the community defined as safe. I draw upon findings from a multi-year study conducted in Spring Hill as part of an ongoing project by the USF Heritage Research Lab (Jackson 2009, 2010).[2]

In Spring Hill, in addition to geographic isolation, control of space was a social expression of what George Lipsitz refers to as the "white spatial imaginary"—the creation of predominantly white residential neighborhoods as normal, natural, undirected, and unscripted (2011, 13). However, control of space was deliberate and managed through processes of racial isolation such as partitioning and behavioral separation, used to minimize or eliminate contact between Black people and whites (Weyeneth 2005, 19). For example, in Sulphur Springs, partitioning as a means of segregating races was actualized through the use of separate or segregated entrances. In those instances, people were forced to use back doors, "colored" and "white only" entrances, and segregated waiting areas and seating areas. Partitioning was also practiced in terms of boundaries such as designated streets operating as racial dividing lines. Water Street, in this case, was a dividing line between Sulphur Springs and Spring Hill. Additionally, behavioral separation as a process of racial segregation was employed through the enforcement of roles and actions that

people took in certain places, such as the designation of certain types of jobs in white homes and business establishments as acceptable for Black people, including maid, housekeeper, nanny, laundress, janitor, and dishwasher.

Despite the ways active exclusion was exercised, Spring Hill also showed the consequential geography of segregation and creative placemaking in the face of injustice. Injustice existed in the very location and identification of Spring Hill as five streets and access to the river. Critical geographer Edward W. Soja puts forward the notion that understanding the spatial organization of a particular place is useful in many applications. He suggests adopting a critical spatial perspective, in order to understand how space was used (2010, 2). I apply this perspective to understand the spatial dynamics in Sulphur Springs, and to examine how active exclusion was articulated in specific places, such as the Arcade, which I discuss below.

This chapter has two goals. First, it highlights how African Americans in Spring Hill created leisure historically in places where people felt free to express themselves without fear of racial exclusion, dismissal, or punishment. Second, it illustrates the relationship between leisure and the church as described by Spring Hill community residents.

White Only a Jim Crow Norm: A Brief History of Sulphur Springs and Spring Hill

I begin by briefly highlighting the tense, segregated conditions under which white-only leisure spaces were constructed and African American residents experienced recreation in Tampa from the 1920s until after integration in 1964. Public facilities were non-existent for African Americans in Tampa during much of the Jim Crow period (1883–1964). For instance, representatives from the YMCA, the Urban League, and the Interracial Commission prepared a report entitled "A Study of Negro Life in Tampa 1927" that shows the city of Tampa providing no public recreation facilities for "Negroes" (Raper, McGrew, and Maya 1927). Although the African American population at the time of the report was 23,323, and although thousands of dollars were spent on park maintenance throughout the city, the report notes that no public park was provided for this population. African Americans were therefore completely excluded from public recreational amenities in the city except in the capacity of servants. The one privately owned site where Blacks could go swimming, Bellair Park in West Tampa, was polluted and unsafe. And for residents of the Spring Hill community, the Sulphur Springs Arcade facility, which will be expanded upon later, was a popular entertainment spot for whites only up until desegregation.

In the 1890s John Mills purchased land around the Springs to develop a park meant primarily for "respectable white people" (Spillane 2007, 8). The park included bathhouses, a pool, and a fish pond. Then in 1898, the U.S. entered the Spanish-American War. After the war, which began and ended in the same year, returning soldiers who had spent time in Tampa before deployment (some as

members of Roosevelt's Rough Riders), decided to settle in the area with their families and take advantage of growing employment opportunities. In 1906 Josiah Richardson purchased a hundred acres from Mills and transformed the park into a winter mecca and spa for northerners. He added attractions such as an alligator farm, a dance pavilion, and shops.

In the early 1920s, 1930s, and 1940s, Sulphur Springs catered to a steady flow of tourists and recreational enthusiasts. They came from Florida and from states such as Michigan and Ohio. People flocked to the natural springs and pool for fun and entertainment. They were also drawn to the area's movies theaters, dog track, stores, churches, and the Hillsborough River for swimming, fishing, and boating. It was a destination of choice. Prior to desegregation, Sulphur Springs blocked non-whites from purchasing homes, and living in, or even recreating in, areas designated as "white only". African Americans and Afro-Cubans in Tampa, for example, lived in communities such as Spring Hill and College Hill and Ybor City. Although they could not recreate in white-only spaces, they worked for white households and/or labored in white-only establishments.

Spring Hill was established as part of the larger, more recognized community of Sulphur Springs (platted in 1911). A 1916 soil survey map of Hillsborough County shows both the Spring Hill and Sulphur Springs geographical contexts. Reverend Henry Mansfield Dillard (1878–1944) was one of the earliest inhabitants of Spring Hill. The Spring Hill Community Association records list the Dillard family's arrival to the community as 1911, and the City Directory places the family's arrival to the community at 1918. The Dillard family lived on the corner of 3rd Street (now Humphrey Street) and Central Avenue. Following WWI, which ended in 1918, there was a surge in Tampa's population. African Americans moved into Spring Hill because they were denied housing in other areas of Sulphur Springs but wanted to be close to places of employment in the growing recreation district in Sulphur Springs as well as in nearby factories, hotels, golf courses, stores, and orange groves.

Spring Hill consists of just five streets. Labeled 1st through 5th and later renamed Yukon, Okaloosa, Humphrey, Eskimo, and Skagway and situated between Busch Boulevard to the north and Waters Avenue to the south, the neighborhood boasted churches, stores, schools, and barbershops. The Spring Hill Missionary Baptist Church, originally located on 3rd Street, which is Humphry Street today, became the original home of the Spring Hill School. The first Black school in the community was constructed on 4th street, now Okaloosa Street. The school was later named Dillard Elementary to honor Reverend Henry Dillard and his success in establishing religious and educational institutions in Spring Hill when previously there were none. As I will demonstrate later in this chapter, understanding the centrality of the church to the social and cultural life of Spring Hill residents is critical to seeing the intersection of churches and the other side of leisure.

In 1953, the city of Tampa annexed Sulphur Springs. Today, the Sulphur Springs Museum and Heritage Center building is located south of Waters Avenue at 1101 East River Cove Street, in the area that would have been off-limits to

African Americans during segregation (see the SSNOP map referenced in note 1). The museum was founded by and operates under the direction of an African American leadership team.

In the 1980s Spring Hill embarked on preservation activities through the Spring Hill Community Association. The Association held meetings on the fourth Saturday of every month and organized annual reunions. At their fifth-year reunion they compiled and distributed the "Memory Book," which discussed the history of Spring Hill and included family genealogies of long-term community residents (Spillane 2007). By reading the Memory Book, members of the USF Research team gained insight into the community that had not been previously published.

In sketching this brief history, I am reminded of the knowledge of Spring Hill shared with me by Mr. Taft Richardson and his family and of Mr. Earl Glymph (both deceased), as well as the conversations with many others that helped bring this community into sharper view. The famous folk artist Mr. Taft Richardson Jr. (1943–2008) and his family have a long history in the Spring Hill community. When he was five, Mr. Taft's family moved to Spring Hill, and he was baptized at Spring Hill Missionary Baptist Church. Mr. Taft is known nationally for creating sculptures out of animal bones; his work is in the Smithsonian Art Museum collection. In May 2007 my students and I interviewed Mr. Taft, his brother Harold, and Mr. Earl Glymph—all long-term residents of Spring Hill. They shared a wealth of information about the community and expressed a deep connection to Spring Hill based on their sense of the importance of community cohesiveness. For example, neighbors in Spring Hill knew one another and people looked out for one another's children. One man recalled church bells ringing when someone in the community died. Others talked about feeling loved and cared for by teachers even though schools were under-funded and lacked many resources. There was an overwhelming desire by those who shared their stories to impress upon us that they were proud to be from Spring Hill and that it remains a deep part of who they are today. In general, the people interviewed expressed that they did not really feel victimized or traumatized because they were always having fun in safe places and with people they were familiar with and who loved, nurtured, and protected them.

The Sulphur Springs Arcade

One of the premier buildings in the community, the Arcade, had an expansive physical presence occupying two blocks. Accessibility to the Arcade was unquestioned in the minds of most white people. And yet it was a segregated place (Jackson 2010). The consequences of segregation, however, were minimized for whites, underscoring what Lipsitz calls the inscription of a "white spatial imaginary" onto a place (Lipsitz 2011, 13). A white spatial imaginary is essentially white entitlement to access. In this case, white as unthinking access to fun through unfettered use of the Arcade, was superimposed on the partitioning of the Arcade as a space which designated Blacks as marginal—a hidden social problem requiring removal or separation. Black access to the Arcade was always conditional, based on

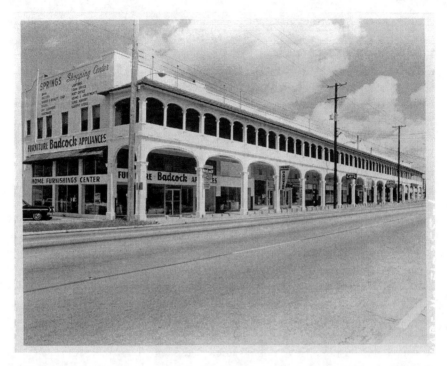

FIGURE 6.1 Sulphur Springs Hotel and Arcade Building, 1933. Formerly located at 8122
 North Nebraska Avenue, Tampa, Florida
Source: Courtesy of U.S. Library of Congress, Prints & Photographs Division, HABS
FL-355, Reproduction number, HABS FLA,29-TAMP,2-.

segregation laws and social norms which enforced separation between whites and
Blacks even in, or especially in, spaces of leisure. Lipsitz looks at the coupling of
race and place and argues that race is produced in and through place (2011, 5). The
Arcade building is a specific example of what Lipsitz is theorizing.

The Arcade building was a major landmark in the Sulphur Springs community
before it was demolished in 1976 (see Figure 6.1). Situated near the mineral waters
of the Hillsborough River, the Arcade, completed in 1927, was a recreational
resort facility and national icon. The second floor housed 39 hotel rooms; 14
apartments and offices; and a host of services from banks to barber shops to stores
of various types. It was touted in *Ripley's Believe or Not* as the first mini-mall in
America.

However, the Arcade was situated on the south side of Waters Avenue. The
cultural context of this location at Waters Avenue was informally known
throughout Spring Hill as a barrier or red line—its implied message was "Do not
cross if you're African American or you could encounter trouble." By cultural
context I mean the symbolic meaning that Waters Avenue held for Black people as
opposed to whites. Weyeneth labels this process of racial separation as "partitioning
through behavioral separation" (2005, 24). The power of Waters Avenue as a

dividing line was so strong that some older Spring Hill residents noted that the first time they crossed Waters Avenue was in 2016, when they attended a function at the new Sulphur Springs Museum and Heritage Center.

The Arcade catered to white patrons only. When community residents were asked to share memories of the Arcade, the tensions of segregation were clearly evident. As the following comments underscore, the Arcade was neither a neutral nor an uncontested site within this community. One white resident who felt an allegiance to the Arcade, and had fond memories of it, recalled, "When you talk to anybody in Sulphur Springs about the past they will say, it broke my heart when they tore down the Arcade" (Jackson 2010, 84). In our conversations with white residents it was clear they had a passion for the place. In response to the same prompt regarding memories of the Arcade, an African American resident said they were happy when it was torn down because they "never got to go" (Jackson 2010, 84). Other residents recalled just how segregated Sulphur Springs was, noting that "Waters Avenue was kind of like a boundary" and "South of Waters Blacks didn't live there" (Jackson 2010, 85). The Arcade was so embedded in white residents' ideas of fun that when the results of interviews with residents were shared Black people's counternarratives came as a surprise. It is interesting to note that whites have celebrated the Arcade as a pinnacle of achievement for the community not only during Jim Crow segregation but also into contemporary times, and continue to remember and honor it as a pure source of fun and entertainment for all.

My use of the term "pure" in relation to the Arcade is intentional because it represents investment in a certain type of relationship with place. Lipsitz (2011) argues that the notion of purity underscores an investment in whiteness. While perhaps unintentional, this investment is in fact built on exclusionary practices. Whites cherished memories of the Arcade as a site of leisure and fun despite the fact that Blacks were excluded. For whites, the Arcade evoked pride, pure joy, and unfettered access. It is only in the critique of the Arcade by Blacks (and shared through Black imaginings and memories) that the Arcade is recognized as a place of fun, exclusion, *and* conditional access. Thus, the Arcade becomes a site for understanding that racism was a part of leisure in this community and others. How leisure is experienced is steeped in racial geographies, and in this understanding the Arcade sits at the intersection of race, place, and leisure.

And yet, in this case and in countless others, the active exclusion operating through specific processes of partitioning and racial isolation did not mean active refusal to pursue leisure by African Americans. Spring Hill is one specific example of how people created alternative sites of leisure in the face of exclusion. Although the history and heritage of Spring Hill has been concealed within public discussions and profiles of the larger community of Sulphur Springs, research conducted by my students and me has gone a long way toward raising awareness of and countering the silence around key aspects of the Spring Hill neighborhood (Jackson 2009, 5–10; Spillane 2007).

In thinking about Spring Hill and its origins as a community, the dominant narrative—that African Americans were constrained or restricted to living on five

streets plus access to the River as a result of segregation—is often a surprise. In using the word "surprise" I draw on the geographer Katherine McKittrick (2006), especially when she notes how Black spatial presence and unexpected encounters with racial geographies of space require the deconstruction of white imaginings of place through assertions of counternarratives (McKittrick 2006, 92–93). In other words, counternarratives and stories of Spring Hill and Sulphur Springs, as shared by African Americans, construct the *what* of the place for Blacks. Their stories and experiences showcase the varied ways attention to leisure through the apparatus of geography provides a critical way of knowing place. Counternarratives portraying Black leisure activities and critiques of leisure illicit surprise and wonder because Black presence is so often left out of critical discussions of space (McKittrick 2006, 92–93). Spring Hill residents pursued leisure and occupied the places they lived and worked in creative ways, within the confines of what Weyeneth (2005) describes as a parallel architectural universe in which duplication was key—there were Black schools, Black stores, and Black churches alongside or within the same neighborhood as white schools, white stores, and white churches. The flip side of defining processes of racial isolation (i.e. duplication) entails focusing on the creative ways African Americans avoided the indignities of racial segregation by actively pursuing leisure and recreation activities.

Creating Leisure and the Centrality of Churches

The question of how African Americans leisure is central to travel and recreation literature. This is because many studies often make assumptions and place emphasis based on quantitative data that make a point of counting Black absence in white-only or historically white-only public and private spaces of recreation and as a result mistakenly theorize reasons for why this was the case. Far fewer data-based studies show what and how African Americans leisured or defined leisure and leisure constraints (Mock 2016). In this section, I focus first on the creative ways African Americans cared for one another and pursued leisure and recreation activities, particularly outside and in nature. Second, I draw attention to the emphasis placed on church associations that are prevalent in interviews with residents (Jackson 2009, 5–10; Spillane 2007).

In order to learn more about the community and to collect information, my students and I organized several events. One event was the Spring Hill Sulphur Springs History and Heritage Day. It was held in February 2007 at George Bartholomew North Tampa Community Center in Spring Hill. Our goal was to create an oral history of Spring Hill and Sulphur Springs. About twenty people from the community were interviewed. Some of those interviewed talked about having picnics at Rowlett Park. Others recalled Rogers Park, which was a place where Black people congregated and felt safe from the oppressions of segregation.[3]

Rogers Park is located adjacent to the Hillsborough River and just across from the railroad tracks and old trellis bridge in Sulphur Springs, and across from Rowlett Park. It was an important recreational spot for Blacks historically. Land for the

park was acquired by the City of Tampa in 1947 via a generous donation from G. D. Rogers, an African American businessman. G. D. Roger's donation of land resulted in the establishment of the Rogers Park Complex by the then mayor Curtis Hixon. The complex was designated as a place for Africans Americans to congregate during segregation, and families frequented the park on Sundays after church for picnics and baseball games. These activities extend both the concept of fellowship to include secular spaces and the geographic space that constituted Spring Hill to beyond the five streets. Rogers Park was one of the only publicly designated parks for African Americans located east of the city. It also boasted a golf course for African Americans.

The park and the golf course are manifestations of active exclusion, and examples of processes of duplication—duplicate Black space provided by state and local government as the cost of maintaining exclusive white space off limits to Blacks (Weyeneth 2005, 15). The Rogers Park Golf Course was completed in 1952 after Mr. Willie Black and several other Black caddies in the Tampa area approached the mayor and asked if they could build the course. These caddies literally designed and built the original nine-hole course. During segregation there was the annual Mid-Winter Classic, part of "The Chittlin' Circuit" for Black golfers, at the park. Golfers from around the country played on the course, which still exists today (Glenn 2010).

In addition to parks, picnics, and baseball games, African Americans cared for one another by providing a range of services through businesses that invested in and were located within the community. For example, throughout the Spring Hill neighborhood different people sold different types of "goodies." There was the "Candy Lady," the "Snow Cone Lady," and the fruit market. The Candy Lady, Maria Ann Carter, who I visited in her home in Spring Hill, reminisced about selling candy to children after school. Also known as "Mama Carter," the Candy Lady sold snacks out of her home, and everyone knew her. On June 2, 2007, Maria Carter's funeral was held at the Spring Hill Missionary Baptist Church on Martin Luther King Boulevard, and her significance as a Black woman within the community was remembered and celebrated. This was because she shielded youth from exposure to racism by opening her home as a store where children could freely experience daily transactions such as buying sweets and play together in her yard. Other families sold vegetables and fruits on a wagon driven up and down the streets of Spring Hill. People also remembered the "Dry-cleaning Man" and his van; he lived on Okaloosa Street and drove around the neighborhood picking up clothes.

Homemade ice cream was also a popular treat. Many people we spoke with recalled having an ice-cream maker at home. Most households had an ice-cream maker because it was cheaper than buying ice cream in the store. And more importantly, people could avoid being demoralized by receiving inferior treatment or having to go around to the back door to make a purchase. And finally, interviewees talked about fishing as a common way for people to both get food and recreate. There were plenty of mullet, sand perch, and brim in the Hillsborough

river. One person said that they ate $2 mullet dinners every Friday. Again drawing from George Lipsitz, these examples of Black refusal to acquiesce in practices of active exclusion play out in what he calls the Black spatial imaginary, a counter-space or alternative way of forming community that privileges "solidarities within between, and across spaces," prioritizing public good over individual interests (2011, 10). Today, Black spatial imaginaries as expressed within the Spring Hill community can provide a way of seeing other places and communities Black people inhabit differently. Spring Hill and the specific efforts taken within this community, within five streets and the river, underscore what Lipsitz describes as "diverse efforts to turn segregation into congregation, to transform divisiveness into solidarity, to change dehumanization into rehumanization" (Lipsitz 2011, 19).

The Black Church and Black Leisure History in Spring Hill

McKittrick (2006) similarly affirms that people are always surprised to find that Black people curated their own spaces. In theorizing leisure, the Black church is often unanalyzed. Adopting a critical spatial perspective means interrogating the Black church and other unconventional sites as ways of knowing and engaging Black leisure history. For example, community member Ms. Johnnie Barlow, who was 54 at the time of the interview, said she was a longtime resident, and that her church was New Bethel AME in Spring Hill. She started attending when she was 11, and commented that the church had just celebrated its 89th anniversary. Barlow grew up during the 1950s and said that while the racial lines were clear, she remains proud to have been a resident of Spring Hill for such a long time. She described her family having to move to Jackson Heights for a time in the 1970s when the highway interstate system, the I-275, was built right through her neighborhood. This highway system, like others built during that time, displaced Black families and destroyed Black communities (Semeuls 2016). During the same period, according to Ms. Barlow, Dillard Elementary School, labeled the "colored" school in city records, was demolished, along with several houses. She added that although Blacks could neither use the whites-only swimming pool on Nebraska Avenue nor frequent the Arcade, Spring Hill Park was the actual heart of the community.

A former resident, Mr. Joel Barnum, aged 55, was a deacon at New St. Matthews Missionary Baptist Church. He discussed his memories of the Hillsborough River in 1960. Barnum said, "The river was so pure, so clean." He would scoop mullet up in a basket because they were so plentiful. On a subsequent visit with Mr. Barnum, who traces his family history to Spring Hill, he took us on a tour of his town. He pointed out many places including the area called "the Bottom," an empty lot across from Spring Hill Church along Taliaferro Avenue that sits, in part, under the I-275. It was called the Bottom because it was situated at the point where the street goes down and then back up, forming a trench that ensures it stays wet most of the time. He referred to the area as "the playground of his youth." He said he and his friends spent all day there playing: swinging on vines, climbing

trees, and going on scavenger hunts. He talked fondly of eating all kinds of fruit—berries, plums, and grapes—while playing and never going hungry.

A focus on leisure in church settings, particularly in the context of organized Black church groups, is downplayed in leisure studies. However, based on discussions with Spring Hill residents, the Black church, in general, proved to be a site of resistance, as well as a venue for trust-building efforts among Black people faced with addressing segregation, a point emphasized in a study by Waller (2010), who notes that leisure is an important but under-examined part of fellowship in African American churches. When recreation is emphasized in literature on churches, it is often discussed in the context of crafting disciplined and moralizing spaces for regulating the body or keeping the body fit and occupied in ways defined appropriate by the church (Holland 2002; Pinn 2008; Stodolska et al. 2014; Waller 2010). This way of characterizing the relationship between recreation and leisure places emphasis on control exerted by the church towards members. However, in this discussion on churches and leisure derived from conversations with Spring Hill residents, emphasis is placed on uses and extensions of church spaces beyond the bricks and mortar of the physical building. Churches were a stronghold against the disciplining demands of racism directed against all Black people. The moral imperative of resistance and the humanizing implications of fun is a significant aspect of the lessons learned from this community.

Churches in the past and in the present play a significant role in the lives of people in Spring Hill. As mentioned earlier, the Spring Hill Community Association held its fifth annual reunion on August 10–13, 1995. Planning meetings for the event were held once a month at one of the various churches in Spring Hill. These were: Spring Hill Missionary Baptist Church (East Humphrey); New Bethel A.M.E. Church (Okaloosa Ave); St. Matthews Missionary Baptist Church (East Yukon Street); and Emmanuel Tabernacle Church (East Yukon Street). The churches listed are recognized as some of the founding churches in Spring Hill. The theme of the reunion was "To Rekindle Love, Unity and Fellowship: Keeping Alive the Ideals of Our Founders." Worship service was an integral part of the festivities and many activities such as a fish fry and the banquet were held in the grounds of one of the church sites.

Churches were often the largest structures in the community so they had the space and power to host activities (Savage 2008). In most cases, Black people owned and managed the churches in their community and could conduct whatever events and activities they wanted. The same was true in Spring Hill where, according to elders in the community, church basements hosted many events and activities for fun. These included activities like drama clubs, dances, movies, roller skating, and even tennis.

People described for us how they would make skate boards by taking roller skates (called Union 5 roller skates), flatten down the heels, and slip them down like a shoe. Then they took the back parts and put them on boards. They would then skate at Spring Hill Church, which at the time had the only piece of concrete sidewalk in Spring Hill. There are still only a limited number of sidewalks in

Spring Hill today. The Spring Hill Church grounds were an especially significant site, showing that the church had resources, could pour concrete, maintain infrastructure, and offered a protective place for children to play. Although Spring Hill Church has since moved, the church's original building still sits at the corner of Central and Humphrey streets.

Earl Glymph (1933–2015), long-term resident and well-known figure in the community and a deacon and participant in the Spring Hill Missionary Baptist Church, told me that he lived on Yukon Street in Spring Hill in a home that had been in his family for 43 years. As previously noted by others, he remembered that there were all kinds of Black businesses in the community, including auto repair shops and laundries that people operated out of their homes. He also recalled swimming in the Hillsborough River and said that people were baptized in the river. His comments reveal how the river was an expansion of geographic and social space. Here we see an example of the extension of the church and of the transition between sacred and secular spaces. In many ways, churches in Spring Hill integrated communities with nature. And within domains of nature such as the Hillsborough River, segregation was obscured or muted, and Black churches cultivated these places as spaces of fellowship, caring, and a renewal of community bonds.

Our research on Spring Hill clearly showed that churches were a crucial aspect of African American life (Savage 2008). They were regularly mentioned in conversations and interviews with residents. For residents, these churches—Spring Hill Church, Spring Hill Baptist Church, Spring Hill Missionary Baptist Church, New Bethel A.M.E., All Nations Outreach Center Church, and the original St. Matthews church—catered to the needs of predominantly African American congregations and provided a place for fellowship, community building, salvation, recreation, leisure, and safety. This discussion has resonances with Du Bois' study, *The Philadelphia Negro*, and particularly his analysis of the sociological role Black churches played in empowerment and community building, which provides a historical precedent for recognizing the significance of church associations and experiences such as those in Spring Hill (Du Bois 1899).

Viewed through the apparatus of geography, my analysis of recreation and leisure in Sulphur Springs highlights the tremendous constraints African Americans faced in pursuit of leisure. However, it also highlights creative strategies of refusal against active exclusion expressed through partitioning, duplication, and temporal separation. The Spring Hill community lived within the context of racially segregated boundaries but creatively used church spaces for movies, theater, and dancing and the Hillsborough River space for fishing, swimming, and baptisms. African Americans developed a wide range of leisure activities, civic organizations, and social and educational institutions as a counter to segregation policies, which many residents experienced first-hand and can still articulate today. Similarly to the splendour associated with the Arcade building and the tension embodied in stories about the Arcade, the history and heritage of the Spring Hill community also exhibits a grandeur, challenging simplistic notions that African Americans passively accepted the inhumanity of segregation.

This chapter has revealed that Black churches serve and have served as a venue for leisure and for trust-building efforts among Black people facing the vagaries of segregation. Black Churches in Spring Hill were a critical domain of not only spiritual strength in the face of oppression but also tangible structures for African Americans to articulate a refusal to be excluded from activities of fun and leisure with friends and family in safe and inviting ways. The example of Spring Hill can serve as a model for thinking about the role other churches, religious organizations, and spiritual groups might play in facilitating and promoting leisure as a form of resistance to oppression.

The varied accounting of church spaces and leisure, and the related types of recreation associated with church affiliation, poignantly unveil complex articulations of power and access to resources often ignored when addressing African Americans and leisure. In order to access African American engagements with leisure, it is important to develop strategies from within communities such as Sulphur Springs and Spring Hill. Centering on this other side of leisure—exploring sites like the Arcade, communities like Spring Hill or Shake Rag in Kentucky, and churches in small and large communities—will enrich the study of leisure.

The analysis of active exclusion via the apparatus of geography provides an expanded set of tools for acknowledging and critiquing processes of racial isolation and separation in the context of leisure. It also describes in unique and nuanced ways what African Americans did in pursuit of leisure during Jim Crow and what can be reimagined today.

Notes

1 Sulphur Springs is roughly situated between Busch Blvd to the North and the Hillsborough River in the South and between Florida Avenue to the east and North 22nd Street on the west. According to the 2010 U.S. Census, there are approximately 5,734 residents in Sulphur Springs and 59% of the residents are African American, 21% Caucasian, and 18% Hispanic. For more information, including a map, consult the Sulphur Springs Neighborhood of Promise (SSNOP) website, www.ssnop.org/our-community/ [Accessed August 12, 2018].

2 Students and faculty at my institution of the University of South Florida have done a great deal of research in Sulphur Springs, including in the historically African American community of Spring Hill. Our goal is to make the Spring Hill story part of the public record at a national level. In 2006, I launched Sulphur Springs Heritage Project as one of the first initiatives of the USF Heritage Research Lab. The goal of the Sulphur Springs Heritage Project, a qualitative research study, conducted in partnership with the Sulphur Springs Museum and Heritage Center Advisory Board, is to document, analyze, and preserve the rich and diverse heritage of the community. A major aim of the project is to fill in gaps in the public record—creating a comprehensive ethnographic and ethnohistorical profile of the community. Two publications document some of the work undertaken in Sulphur Springs and Spring Hill and are used in this discussion. See: Jackson 2010, 2009. In addition to this research, USF students (starting in 2006) have created a logo design, a website, and an oral history database for the Sulphur Springs Museum, as well as produced videos and podcast programs documenting the history and heritage of the Sulphur Springs community in direct response to project goals identified by the Sulphur Springs Museum and Heritage Center and community residents.

[USF research milestones: 2004—Connie Brown MA thesis and oral history of ladies from Sulphur Springs; 2007—Courtney Spillane's M.A. thesis on heritage preservation in Sulphur Sprints and Seminole Heights published; and History and Heritage Day held in Spring Hill; 2010—Jessica Rubano's undergraduate research report on the Mann-Wagnon family and will completed. 2015–17— Preston LaFarge, Vivian Gornik, and Melissa Sedlacik researched and curated an exhibit for the Smithsonian Waterways exhibit opening at the Sulphur Springs Museum in consultation with Drs. Antoinette Jackson and Elizabeth Bird. 2018—USF graduate students April Min and Lisa Armstrong research content for and curate a poster exhibit on religious and educational institutions in Spring Hill for a Juneteenth Celebration held at the Sulphur Springs Museum in consultation with Drs. Jackson and Bird.]

3 Sulphur Springs boundaries are Rowlett Park to the east, Florida Avenue to the west, Busch Boulevard to the north, and the Hillsborough River to the south. Rowlett Park is located at 2410 East Yukon Street, and part of the park borders the Hillsborough River. It is a large and heavily used park with nature trails, a playground, and facilities for picnics, canoeing, roller skating, racquetball, baseball, and biking. It was founded in 1923 and named in honor of Dr. W. M. Rowlett, who at that time was chairman of the City of Tampa Park Board. Rowlett Park was a white-only park and off-limit to Black people during segregation. Rogers Park is located just across the Hillsborough River from Rowlett Park. When established in 1947, it was one of the only parks where African Americans could picnic in Tampa. Today, Rogers Park is the site of Rogers Park Golf Course, located at 7910 North 30th Street (now North Willie Black Drive). The State of Florida now lists Rogers Park Golf Course on the National Register of Historic Places.

7

CONCLUSION

Because leisure with respect to African Americans is often underimagined and undertheorized, this book has focused on how African Americans have constructed leisure, particularly during the period of racial segregation. The importance of this focus rests on the fact that mythologies about Blacks and leisure, or simplistic stories about long ago days and times, continue to prevail. The end result is a limited perspective that masks complex dynamics of Black spatial presence, geographic and architectural creativity, land use strategies, and tactical approaches to managing and organizing space by people confronted with segregation and an ideology of white supremacy.

This book has shown that Black people have always leisured or sought respite and relief from work. They have always pursued opportunities for joy even when confronted with the most inhumane conditions—slavery and segregation. I have argued that the pursuit of leisure is an affirmation of humanity. This book redresses scholars' lack of attention to this topic. The complexities of race in the context of leisure are significant as well as fascinating to explain.

To make the case of the significance of the pursuit of leisure and Black participation, I have amplified what it means when Black people, who have been marginalized through state-sanctioned segregation, refuse to accept this status and construct vibrant spaces of leisure and recreation. I have centered on how they act collectively and/or individually at a familial or community level to resist authoritative measures and social controls.

There are other ways of approaching this topic and many more examples to be shared—some with less compelling outcomes. And each is complicated by different decisions regarding when to resist or refuse the measures and controls noted above, and how. These differences are based on age, class, gender, or differential access to time, resources, and other means of power. However, the various cases presented in this book portray what African Americans did in terms of leisure when they *imagined*

something different and beyond the limitations imposed by segregation, and then created and lived it. In the context of active exclusion, I interpret what they did as a politic of refusal. Like scholars Audra Simpson (2014, 2016) and Carole McGranahan (2016), I think there are generative aspects of refusal that should be reflected upon. Importantly, there are lessons to be learned by examining refusals that rest outside the domain of formal social movements. In other words, we can look to the everyday lives of Black people to find expressions of refusal in the context of leisure.

I have situated the other side of leisure in terms of three areas. First, I theorized Black people's leisure in the U.S. through the lens of active exclusion, with a particular focus on how active exclusion was operationalized through various apparatuses or domains of power—social control, architecture, law, and geography. Second, I broadened the scope of what constitutes leisure and what it means to pursue leisure based on studies of families, communities, and histories. These studies underscore that where we look for information and how we look for information are equally important. And third, I have argued that in spite of active exclusion and the ways it was executed, Black people resisted and refused segregation and dehumanization.

Segregation and processes of racial isolation played out for African Americans in varying yet specific ways. African Americans were blocked from pursuing leisure in spaces designated as white only, which at any given time could be any given space. I proposed active exclusion as a theoretical frame for analyzing how racial isolation and white spatial control was accomplished systemically, and in the examples throughout this book, I demonstrated how active exclusion is operationalized through various apparatuses or domains of power.

National narratives and projects about heritage, tourism, and leisure have typically avoided a critical race critique. These narratives and projects have also, more often than not, normalized the racial exclusion embedded in quantitative metrics and statistics showing absence or underrepresentation. For example, scholars focused on tourism and leisure have mostly ignored Black presence and participation as cooks, maids, valets, and laborers in white leisure spaces. They have also silenced or failed to incorporate Black critique, critical observations, stories concerning navigation in white-only spaces, and the multiplicity of ways Black people created and participated in leisure activities. Limited views of Black involvement in leisure continues to be reproduced in scholarship (Weber and Sultana 2013b; Taylor 1989; West 1993).

In the preceding chapters I have illustrated the realities of active exclusion by drawing from the lived experiences of specific people and communities with the aim of bringing them to the forefront of leisure and travel studies. I have shown that in some cases the outcome of active exclusion has resulted in a rendering of Black presence as exceptional rather than commonplace. This was the case with regard to outdoor recreation activities—such as caving at Mammoth Cave in Kentucky and fishing at the fish camp in Florida. By focusing on who is excluded from places of recreation, leisure, culture, and tourism, and by asking under what circumstances they are historically and presently excluded, the reality of systemic

barriers to access and to the pursuit of leisure embedded in American cultural norms and laws is exposed. At the same time, however, active exclusion does not completely define Black leisure activities. Black people have defined leisure in many ways and on their own terms.

With regard to the second focus of the book, which seeks to broaden the scope of what we consider leisure, I utilized genealogies, family histories, oral histories, interviews and stories about home, work, places of fellowship, forms of entertainment, and locations of fun to show the many ways that Black people leisured. The places that African Americans choose to leisure are not always places that leisure scholars have considered relevant. This book has consequently been a critical methodological intervention. Participation in leisure, recreation, and tourism activities are seen as markers of culture or markers of who is considered cultured. In this context I proposed a view of leisure that does not simply focus on white leisure space and is not reconciled through visitor logs. In fact, I proposed that we capture the experiences and meaning of leisure beyond quantitative metrics resulting from counting the number of visitors, number of hotels, hotel occupancy rates, number and types of activities, and dollars spent.

Thus, methodologically, I have suggested focusing on the everyday lives of people as a central way of learning about African American participation in leisure. A critical ethnographic and ethnohistorical orientation to data collection and presentation helps rethink and reimagine questions asked about who leisured and how, helps redevelop a holistic understanding of leisure, and helps resituate findings in historical context. A much richer view of the other side of leisure is produced when people recount their experiences and/or when their lived experiences are made central to interpretations of the past. Numerical metrics obscure what is being interpreted; what is remembered, and how; what made one place different from another; how people and families are connected; what made an establishment unique; why certain places were frequented or avoided; and finally, what impacted the choices made and options available at certain times in history.

This book flagged both underrepresented and unexpected sites of leisure in places like Mammoth Cave, Kentucky, and the Marsalis Mansion Motel in New Orleans. Additionally, the methodological approach investigated questions about the use of plantations as sites of leisure and demonstrated how these sites can be seen from multiple perspectives. The rich narratives of the families and communities connected to Kingsley Plantation, such as the Christopher and Daniels families in Florida, highlight ways in which Black labor and entrepreneurship can inform interpretations of post bellum plantation spaces as sites of recreation. In the case of Spring Hill in Tampa, Florida, we see the role that autonomy played in the leisure lives of African Americans in part because of church resources and affiliations. These observations, emerging from the methods utilized, enrich discussions of leisure and work to further qualify what the pursuit of leisure looks like in ways not readily apparent in quantitative assessments. In sum, examples presented throughout the book highlight that every group claims the right to leisure and acknowledges the centrality of leisure as an expression of their humanity.

Refusing Segregation in the Pursuit of Leisure

In describing the third focal point of the book, I make deliberate scholarly use of the term *refusal*, drawing especially on Audra Simpson's definition and application. She defines refusal as a political choice and states that her decision as an anthropologist to identify accounts of refusal in ethnographies and to foreground the calculus of whether or not to voice and prioritize it is a deliberate act in her work (Simpson 2007, 70). Along with Simpson (2014, 2016), McGranahan (2016) informs how I have defined refusal: the articulation and action of marginalized people, through collective or individual action, to turn away from or reject the legitimacy of various state sanctioned authorities or laws to govern their lives and uphold and affirm their humanity. Refusal, as analyzed in the cases comprising this book, is both the conscious negation of ideologies of white supremacy and marginalization of Black humanity and specific actions taken to counter artificial limits on what is possible.

There are implications of studying refusal and resistance and I am conscious of how these concepts shape my work. Doing work as an anthropologist in the context of a politic of refusal means going against the grain of storytelling in national narrative-making aimed at creating public memory (Jackson 2019). National narratives at public sites of history and heritage often erase and sanitize stories of resistance in order to make them more palatable for general white audiences. This is as opposed to emphasizing the ways in which people negated the dictates of marginalizing practices and choose to do something else, live another way, or even voice criticism.

I am also sensitive to the fact that my use of refusal comes from the perspective of an academic engaged in interpreting people's lives and stories. The people, families, and communities discussed and described here may or may not choose to analyze their lives as I have interpreted them—as a politic of refusal. However, for me it remains an instructive frame from which to consider other possibilities, other knowledges that can emerge from an articulation of refusal versus a positionality of inclusion or assimilation. For example, I have situated the Christopher family and their association with the Kingsley Plantation in the context of a politics of refusal because they did not play by the rules of racial segregation of their time. They ignored legal dictates governing racial intermarriage and formed families as they chose. They conveyed their freedom of movement against social controls and the policing of the norms and policies of racial separation with such a degree of clarity and consciousness. Their conscious decisions influenced their kinship relationships and business endeavors. To ignore the acts of refusal that emerged from their oral histories would dilute the reality of their lived experiences.

Importantly, I position refusal as a means of describing the active use of space or spatial claims though deliberate practice and acts of empowerment. Such a view requires seeing and acknowledging Black reimagining of space. For instance, people using the church basement as a roller rink in Spring Hill or the creation of a hotel for Black cave tourists in Kentucky. To get at the Black reimagining of space

in these instances requires us to seek knowledge about what goes on inside structures—to ask how people make home and fun within spaces where they live, work, and find fellowship (Gooden 2016). It also requires us to expand the archives to include labor and knowledge by non-white people (Wilson and Rose 2017); to document imaginative responses to segregation and the development of alternative spaces (Weyeneth 2005); and to shift our focus to discussions of where people live and how they move through the spaces they inhabit (Wilson 2017). In this context, it is then fundamental to consider how Blacks shape space. Here, I draw upon the work of anthropologist Helen Regis (2001) and her discussion of second line parading in New Orleans. Regis analyzed the second line parade as a form of creativity and control in struggles over urban space by Black people. Regis argued that these weekly parades are a means to "reclaim urban streets" (Regis 2001, 756) and "underline the semantic reconquest of space" (Regis 2001, 757). Similarly, I conclude that Black use of leisure space circumvents social and geographic marginalization and has important political implications.

I have taken up the challenge of finding out what can be learned for the present and what can be imagined for the future by prioritizing refusal not only at the level of collective social movements but also at the level of the everyday in the pursuit of leisure. Black people pursued leisure as their right. In doing so, they reshaped and renegotiated space and refused second-class citizenship. The paradox of liberty is reconciling the denial of basic human rights to some based on race with the Declaration of Independence's boldly universal assertion of humanity and what it means to be free. The pursuit of leisure or right of unbounded exploration, underscored in the Declaration as the "pursuit of happiness," has in fact been conditionally granted based on race. This book has exposed gaps between the pursuit of these basic rights and the structural markers and reminders of transatlantic slavery and segregation that have served to impede this progress. These gaps in access are embedded in some of our most public places of recreation and tourism and in some of our most recognizable and seemingly benign activities of travel—access to a car, gas, and places to stop, eat, and rest.

Importantly, it has also situated the pursuit of leisure as an affirmation and assertion of humanity. Focusing on a politic of refusal and the power of resistance in the area of leisure helps highlight the range of ways people, families, and communities maintained their humanity through everyday interactions despite exclusionary laws and social practices. This is important because histories of African-descended people and communities are often silenced or missing from the public record. And when encountered, it is with surprise (McKittrick 2006, 92–93). Finally, my book forces us to ask new questions about the democratizing of knowledge production concerning leisure with respect to underrepresented communities.

Although this book focuses heavily on the past, its lessons remain relevant today. I am reminded of the McKinney, Texas, pool party incident, for example, and a series of events that unfolded that resulted in the classification of Black teenagers as unauthorized trespassers in a space of leisure[1]. On June 8, 2015, I watched my

television screen in horror as a news video showed an armed police officer put his knee into the back of a bikini-clad Black teenage girl to restrain her. She was a young woman, who prior to her contact with the officer was simply attending a pool party in a middle-class suburban neighborhood in McKinney, Texas with many other teenagers. This incident impassioned me to move forward with this book. And as the policing of Black people engaged in legitimate and mundane forms of leisure from cookouts in public parks to playing music to talking too loud on a wine tourism bus continues to occur, I am brought back to the beginnings of this book, and especially Strom Thurmond's 1948 speech as a U.S. presidential candidate and proponent of segregation. He issued a call to keep spaces of social and cultural import off-limit to Black people and for the regulation of their access to and activity within these spaces.

However, on the other side of leisure there is a legacy of refusal, a prescriptive for crafting anew a way forward. When he began publishing the *Green Book*, Victor Green predicted that there would come a day when it would no longer be needed. That day did come. But the need to enact resistance and refusal in different ways towards new publics remains.

Note

1 An article entitled "McKinney, Texas, and the Racial History of a American Swimming Pool" by Yoni Appelbaum appeared in the *Atlantic* magazine shortly after the incident (June 8, 2015). Part of the incident was caught on video and broadcast nationally as part of the news. See Appelbaum (2015).

REFERENCES

Adams, Joey. 1966. *The Borscht Belt*. New York: Bobbs-Merrill.

Alexander, Michelle. 2010. *The New Jim Crow: Mass Incarceration in the Age of Colorblindness*. New York: New Press.

Algeo, Katie. 2013. "Underground Tourists/Tourists Underground: African American Tourism in Mammoth Cave." *Tourism Geographies* 15(3): 380–404.

Alston, Marion Christopher. 1994. *Christophers and Their Descendants*. Family history album. Distributed to Christopher family members, Jacksonville, FL.

Alston, Marion Christopher. 1998. Interview with University of Florida Ethnographic Field Team, National Park Service sponsored Kingsley Heritage Celebration and Family Reunion. Fort George Island, FL, October 10–11. In *Ethnohistorical Study of Kingsley Plantation Community*, by Antoinette Jackson with Allan F. Burns, 51–55. Atlanta, GA: Cultural Resources Division, Southeast Regional Office, National Park Service.

Appelbaum, Yoni. 2015. "McKinney, Texas, and the Racial History of American Swimming Pools." *The Atlantic*, June 8.

Aptheker, Herbert. 1951. *A Documentary History of the Negro People in the United States*. New York: Citadel Press.

Baker, Lee D. 1998. *From Savage to Negro: Anthropology and the Construction of Race, 1896–1954*. Berkley: University of California Press.

Barry, Brian. 2002. "Social Exclusion, Social Isolation, and the Distribution of Income." In *Understanding Social Exclusion*, edited by John Hills, Julian Le Grand, and David Piachaud, 13–29. New York: Oxford University Press.

Battle-Baptiste, Whitney. 2011. *Black Feminist Archaeology*. London and New York: Routledge.

Belasco, W. J. 1997. *Americans on the Road: From Autocamp to Motel, 1910–1945*. Baltimore, MD: Johns Hopkins University Press.

Broach, Drew. 2018. "Historic Site of Marsalis Mansion Motel Going to Dogs: Report." *NOLA.com/The Times-Picayune*, September. Accessed February 16, 2019. www.nola.com/business/index.ssf/2018/09/marsalis_motel_going_to_dogs.html.

Brown, Jacqueline Nassy. 2000. "Enslaving History: Narratives on Local Whiteness in a Black Atlantic Port." *American Anthropological Association* 27(2): 340–370.

Brown, Nikki. 2010. "Jim Crow and Segregation." In *64 Parishes*, edited by David Johnson. Louisiana Endowment for the Humanities, 2010–. Accessed August 18, 2019. https://64parishes.org/entry/jim-crowsegregation.

Brown, Ralph and John F. Toth Jr. 2001. "Natural Resource Access and Interracial Associations: Black and White Subsistence Fishing in the Mississippi Delta." *Southern Rural Sociology* 17: 81–110.

Bruner, Edward M. 2005. *Culture on Tour: Ethnographies of Travel*. Chicago, IL: University of Chicago Press.

Candacy, Taylor. 2016. "The Roots of Route 66." *The Atlantic*, November 3. Accessed September 27, 2018. www.theatlantic.com/politics/archive/2016/11/the-roots-of-route-66/506255/.

Cannella Schmitzer, Jeanne. 1995. "CCC Camp 510: Black Participation in the Creation of Mammoth Cave National Park." *Register of the Kentucky Historical Society* 93(4): 446–464.

Carter, Perry L. 2008. "Coloured Places and Pigmented Holidays: Racialized Leisure Travel." *Tourism Geographies* 10(3): 265–284.

Chafe, William H. 2001. *Remembering Jim Crow: African Americans Tell about Life in the Segregated South*. New York: The New York Press.

Chambers, Erve. 2000. *Native Tours: The Anthropology of Travel and Tourism*. Long Grove, IL: Waveland Press. [See pp. 34–35, 69.]

Chambers, Erve. 2010. *Native Tours: The Anthropology of Travel and Tourism*. Long Grove, IL: Waveland Press.

Cheng, Irene, Charles L. Davis II, and Mabel O. Wilson. 2017. "Racial Evidence." *Journal of the Society of Architecture* 76(4): 440–442. Accessed July 23, 2019. https://jsah.ucpress.edu/content/76/4/440.

Cole, Johnnetta B. 2000. "Interview with Antoinette T. Jackson, Atlanta, Georgia, October 3." In *Ethnohistorical Study of Kingsley Plantation Community*, by Antoinette Jackson with Allan F. Burns, 31. Atlanta, GA: Cultural Resources Division, Southeast Regional Office, National Park Service.

Conan, Neal. 2010. "'Green Book' Helped African Americans Travel Safely." *NPR* (National Public Radio), September 15. Accessed November 23, 2018. www.npr.org/templates/transcript/transcript.php?storyId=129885990?storyId=129885990.

Crespino, J. 2012. *Strom Thurmond's America*. New York: Hill and Wang.

Cronon, William (ed.). 1995. *Uncommon Ground: Rethinking the Human Place in Nature*. New York: W. W. Norton & Co.

Cutler, James E. 1905. *Lynch Law*. New York: Longmans Green.

Daniels, James. 2001. "Interview with Marsha Phelts, Fort George Island, Florida, December 15." In *Ethnohistorical Study of Kingsley Plantation Community*, by Antoinette Jackson with Allan F. Burns, 55–57. Atlanta, GA: Cultural Resources Division, Southeast Regional Office, National Park Service.

Davidson, James. 2007. "University of Florida Archeological Field School 2007 Report of Investigations: Kingsley Plantation, (8DU108) Timucuan Ecological and Historic Preserve National Park, Duval County, Florida." Gainesville, FL: University of Florida.

Davies, Carole Boyce. 2013. *Caribbean Spaces: Escape Routes from Twilight Zones*. Urbana: University of Illinois Press.

Davis, Charles L. II. 2018. "Blackness in Practice: Toward and Architectural Phenomenology of Blackness." *Log* 42 (Winter/Spring). Accessed July 23, 2019. https://raceandarchitecture.com/2018/05/21/blackness-in-practice/.

Dawson, Kevin. 2006. "Enslaved Swimmers and Divers in the Atlantic World." *Journal of American History* 92(4): 1327–1355.

Dilsaver, Lary M. 2016. *America's National Park System: The Critical Documents*, 2nd ed. Lanham, MD: Rowman & Littlefield.

Drake, St. Clair. 1987. *Black Folk Here and There: An Essay in History and Anthropology*, vol. 2. Los Angeles: University of California Center for Afro-American Studies.

Driskell, Jay. 2015. "An Atlas of Self-Reliance: The Negro Motorist's Green Book (1937–1964)." O Say Can You See? Smithsonian American History Series, July 30. Accessed September 29, 2017. http://americanhistory.si.edu/blog/negro-motorists-green-book.

Du Bois, W. E. B. 1899. *The Philadelphia Negro: A Social Study*. Philadelphia: University of Pennsylvania Press.

East Florida Papers. Gainesville: University of Florida PKY Library of Florida History. Microfilm file 55A, reel 97.

Ellsworth, Scott. 1992. *Death in the Promised Land: The Tulsa Race Riot 1921*. Baton Rouge: Louisiana State University Press.

Fett, Sharla M. 2002. *Working Cures: Healing, Health, and Power on Southern Slave Plantations*. Chapel Hill: University of North Carolina Press.

Fields, Edda L. 2008. *Deep Roots: Rice Farmers in West Africa and the African Diaspora*. Bloomington: Indiana University Press

Finkelman, Paul. 2014. "The Long Road to Dignity: The Wrong Segregation and What the Civil Rights Act of 1964 Had to Change." *Louisiana Law Review* 74(4): 1039–1094.

Finney, Carolyn. 2014. *Black Faces, White Spaces: Reimagining the Relationship of African Americans to the Great Outdoors*. Chapel Hill: University of North Carolina Press.

Fisher, Colin. 2006. "African Americans, Outdoor Recreation, and the 1919 Chicago Race Riot." In *To Love the Wind and the Rain: African Americans and Environmental History*, edited by Dianne D. Glave and Mark Stoll, 63–76. Pittsburgh, PA: University of Pittsburgh.

Fletcher, Patsy Mose. 2015. *Historically African American Leisure Destinations Around Washington, D.C.* Charleston, SC: The History Press.

Floyd, M., F. Hochan Jang, and F. P. Noe. 1997. "The Relationship between Environmental Concern and Acceptability of Environmental Impacts among Visitors to Two U.S. National Park Settings." *Journal of Environmental Management* 51: 391–412.

Floyd, Myron F. 1998. "Getting Beyond Marginality and Ethnicity: The Challenge for Race and Ethnic Studies in Leisure Research." *Journal of Leisure Research* 30(1): 3–22.

Floyd, M. F. 2001. "Managing National Parks in a Multicultural Society: Searching for Common Ground." *The George Wright FORUM* 18(3): 41–51.

Foote, Kenneth E. 2012. "Editing Memory and Automobility & Race: Two Learning Activities on Contested Heritage and Place." *Southeastern Geographer* 52(4): 384–397.

Ford, Iris Carter. 2001. "The Travel and Travail of Negro Showpeople." *Anthropology and Humanism* 26(1): 35–45.

Foster, Mark S. 1999. "In the Face of "Jim Crow": Prosperous Blacks and Vacations, Travel, and Outdoor Leisure, 1890–1945." *The Journal of Negro History* 84(2): 130–149.

Foucault, Michel. 1980 [1972]. *Power/Knowledge: Selected Interviews and Other Writings 1972–1977*. New York: Pantheon Books.

Franz, Kathleen. 2004. "'The Open Road': Automobility and Racial Uplift in the Interwar Years." In *Technology and the African-American Experience: Need and Opportunities for Study*, edited by Bruce Sinclair, 131–154. Cambridge, MA: MIT Press.

Frederickson, K. 2001. *The Dixiecrat Revolt and the end of the Solid South 1932–1968*. Chapel Hill: University of North Carolina Press.

Galatowitsch, Diane. 2011. Biographical note, Ellis L. Marsalis Sr. papers, Amistad Research Center, New Orleans, Louisiana.

Gilmore, Tim. 2016. "New Berlin: Goat Island and Christopher's Pier". *Jax Pscho Geo*, September 12. Accessed November 23, 2018. https://jaxpsychogeo.com/north/new-berlin-goat-island-and-christophers-pier/

Giltner, Scott E. 2008. *Hunting and Fishing in the New South: Black Labor and White Leisure after the Civil War*. Baltimore, MD: Johns Hopkins University Press.

Gilroy, Paul. 2001. "Driving While Black." In *Car Cultures*, edited by Daniel Miller, 81–104. New York: Berg Publishers.

Glen, Rhonda. 2010. "Rogers Park and Willie Black's Dream." The United States Golf Association (USGA), September 6. Accessed January 5, 2019. www.usga.org/articles/2010/09/rogers-park-and-willie-blacks-dream-56567.html.

Gooden, Mario. 2016. *Dark Space: Architecture, Representation, Black Identity*. New York: Columbia Books on Architecture and the City.

González-Tennant, Edward. 2018. *The Rosewood Massacre: An Archaeology and History of Intersectional Violence*. Gainesville: University Press of Florida.

Grant, Elizabeth. 2005. "Race and Tourism in America's First City." *Journal of Urban History* 31(6): 850–871.

Greater New Orleans Community Data Center. 2002a. "Bywater Neighborhood." Last modified April 23, 2002. www.datacenterresearch.org/pre-katrina/orleans/7/19/index. html.

Greater New Orleans Community Data Center. 2002b. "Dixon Neighborhood Snapshot." Last modified October 5, 2002. www.datacenterresearch.org/pre-katrina/orleans/3/36/snapshot.html.

Greater New Orleans Community Data Center. 2002c. "Hollygrove Neighborhood Snapshot." Last modified October 5, 2002. www.datacenterresearch.org/pre-katrina/orleans/3/12/snapshot.html.

Greater New Orleans Community Data Center. 2003. "Little Woods Neighborhood Snapshot." Last modified February 10, 2003. www.datacenterresearch.org/pre-katrina/orleans/9/49/snapshot.html.

Greater New Orleans Community Data Center. 2004. "Central City Neighborhood Snapshot." Last modified June 23, 2004. www.datacenterresearch.org/pre-katrina/orleans/2/61/snapshot.html.

Greater New Orleans Community Data Center. 2006. Accessed May 14, 2008. www.gnocdc.org/.

Greater New Orleans Community Data Center. 2010. "Pre-Katrina Data Center Web Site." Last modified November 3, 2010. www.datacenterresearch.org/pre-katrina/prekatrinasite.html.

Green Book Series. 1936–1967. Schomburg Center for Research in Black Culture, New York Public Library Digital Collections. New York: Victor H. Green & Co. Accessed 28 October 2018. https://digitalcollections.nypl.org/collections/the-green-book#/?tab=about.

Green, Victor H. 1948. Schomburg Center for Research in Black Culture, Manuscripts, Archives and Rare Books Division, New York Public Library. "The Negro Motorist Green Book: 1948," New York Public Library Digital Collections. Accessed September 9, 2019. http://digitalcollections.nypl.org/items/6fa574f0-893f-0132-1035-58d385a7bbd0.

Green, Victor H. 1949. Schomburg Center for Research in Black Culture, Manuscripts, Archives and Rare Books Division, New York Public Library. "The Negro Motorist Green Book: 1949," New York Public Library Digital Collections. Accessed September 9, 2019. http://digitalcollections.nypl.org/items/9dc3ff40-8df4-0132-fd57-58d385a7b928.

Green, Victor H. 1953. Schomburg Center for Research in Black Culture, Manuscripts, Archives and Rare Books Division, The New York Public Library. "The Negro Motorist Green Book: 1953," New York Public Library Digital Collections. Accessed September 9, 2019. http://digitalcollections.nypl.org/items/2bc86d90-92d0-0132-e771-58d385a7b928.

Green, Victor H. 1957. Schomburg Center for Research in Black Culture, Manuscripts, Archives and Rare Books Division, New York Public Library. "The Negro Motorist

Green Book: 1957," New York Public Library Digital Collections. Accessed September 9, 2019. http://digitalcollections.nypl.org/items/089a5a60-848f-0132-a7aa-58d385a7b928.

Greenbaum, Susan. 2002. *More than Black: Afro-Cubans in Florida*. Gainesville: University Press of Florida.

Hackley & Harrison Publishers. 1930. *Hackley & Harrison's Hotel and Apartment Guide for Colored Travelers: Board, Rooms, Garage Accommodations, etc. in 300 Cities in the United States and Canada*. Philadelphia, PA: Hackley & Harrison.

Hall, Michael Ra-shon. 2014. "The Negro Traveller's Guide to a Jim Crow South: Negotiating Racialized Landscapes During a Dark Period in United States Cultural History, 1936–1967." *Postcolonial Studies*, 17(3), 307–319.

Handler, Richard and Eric Gable. 1997. *The New History in an Old Museum*. Durham and London: Duke University Press.

Hart, John Fraser. 1960. "A Rural Retreat for Northern Negroes." *Geographical Review* 50(2): 147–168.

Hatchett, Louis and Michael Stern. 2014. *Duncan Hines: How a Traveling Salesman Became the Most Trusted Name in Food*. Lexington: University of Kentucky Press.

Herbert, Bob. 2002. "Racism and the G.O.P." *New York Times*, December 12. Accessed September 3, 2019. www.nytimes.com/2002/12/12/opinion/racism-and-the-gop.html.

Higham, John. 1957. "Social Discrimination against Jews in America, 1830–1930." *Publications of the American Jewish Historical Society* 47(1): 1 33.

Hines, Duncan. 1936. *Adventures in Good Eating*, 1st ed. Bowling Green, KY: Adventures in Good Eating.

Hines, Duncan. 1938–1947. *Lodging for a Night. A Duncan Hines Book. Good Places to Spend the Night: Hotels, Inns, Overnight Guest Houses and Modern Auto Courts*. Bowling Green, KY: Adventures in Good Eating.

Hines, Duncan. 1948. *Vacation Guide*. New York: Duncan Hines.

Holland, Jearold Winston. 2002. *Black Recreation: A Historical Perspective*. Chicago, IL: Burnham/Rowman & Littlefield.

Hollingshead, A. B. 1941. "The Concept of Social Control." *American Sociological Review* 6 (2): 217–224.

Hylton, Kevin and Namita Chakrabarty. 2011. "Introduction: 'Race' and Culture in Tourism, Leisure and Events." *Journal of Policy Research in Tourism, Leisure and Events* 3(2): 105–108.

Jackson, Antoinette. 2001. "Heritage-Tourism and the Historical Present: Africans at Snee Farm Plantation." *Southern Anthropologist* 28(1): 12–27.

Jackson, Antoinette. 2003. "Africans at Snee Farm Plantation: Informing Representations of Plantation Life at a National Heritage Site." In *Signifying Serpents & Mardi Gras Runners: Representing Identity in Selected Souths*, edited by Celeste Ray and Luke Eric Lassiter, 90–109. Athens: University of Georgia Press.

Jackson, Antoinette. 2004. "African Communities in Southeast Coastal Plantation Spaces in America." Ph.D dissertation, University of Florida.

Jackson, Antoinette with Allan F. Burns. 2006. *Ethnohistorical Study of Kingsley Plantation Community*. National Park Service Contract No. Q5038000491. Atlanta, GA: Cultural Resources Division, Southeast Regional Office, National Park Service. Accessed November 25, 2018. www.nps.gov/ethnography/research/docs/timu_ethno.pdf.

Jackson, Antoinette. 2009. "Conducting Heritage Research and Practicing Heritage Resource Management on a Community Level: Negotiating Contested Historicity." *Practicing Anthropology* 31(3): 5–10.

Jackson, Antoinette. 2010. "Changing Ideas about Heritage and Heritage Management in Historically Segregated Communities." *Transforming Anthropology* 18(1): 80–92.

Jackson, Antoinette. 2011a. "Diversifying the Dialogue Post Katrina: Race, Place, and Displacement in New Orleans, USA." *Transforming Anthropology* 19(1): 3–16.

Jackson, Antoinette. 2011b. "Shattering Slave Life Portrayals: Uncovering Subjugated Knowledge in US Plantation Sites in South Carolina and Florida." *American Anthropologist* 13(3): 448–462.

Jackson, Antoinette. 2012. *Speaking for the Enslaved: Heritage Interpretation at Antebellum Plantation Sites*. New York: Routledge.

Jackson, Antoinette. 2014. "Intangible Cultural Heritage and Living Communities." *Anthropology News* 55(3): e21–e61.

Jackson, Antoinette. 2016. "More Than Scenery: National Parks Preserve Our History and Culture." *Anthropology Now*. Posted on August 2. http://anthronow.com/online-arti cles/more-than-scenery.

Jackson, Antoinette T. 2019. "Remembering Jim Crow, Again – Critical Representations of African American Experiences of Travel and Leisure at U.S. National Park Sites." *International Journal of Heritage Studies* 25(7): 671–688. Posted online on November 10, 2018. https://doi.org/10.1080/13527258.2018.1544920.

Jackson, Kenneth T. 1967. *The Ku Klux Klan in the City 1915–1930*. New York: Oxford University Press.

Jacoby, Karl. 2003. *Crimes against Nature: Squatters, Poachers, Thieves, and the Hidden History of American Conservation*. Berkeley and Los Angeles, CA: University of California Press.

Jefferson, Alison Rose. 2009. "African American Leisure Space in Santa Monica: The Beach Sometimes Known as the 'Inkwell'." *Southern California Quarterly* 91: 155–189.

Jochum, Kimberly and Michael Mizell-Nelson. N.d. "Segregation in City Park." *New Orleans Historical*. Accessed August 17, 2018. http://neworleanshistorical.org/items/show/203.

Johnson, Cassandra Y., J. M. Bowker, Donald B. K. English, and Dreamal Worthen. 1998. "Wildland Recreating in the Rural South: An Examination of Marginality and Ethnicity Theory." *Journal of Leisure Research* 30(1): 101–120.

Johnson, Mildred Christopher. 2001. Interview with Antoinette T. Jackson. Jacksonville, Florida, October 11. In *Ethnohistorical Study of Kingsley Plantation Community*, by Antoinette Jackson with Allan F. Burns, 51–55. Atlanta, GA: Cultural Resources Division, Southeast Regional Office, National Park Service.

Kahrl, Andrew W. 2012. *The Land Was Ours: African American Beaches from Jim Crow to the Sunbelt South*. Cambridge, MA: Harvard University Press.

Kahrl, Andrew W. 2013. "The 'Negro Park' Question: Land, Labor, and Leisure in Pitt County, North Carolina, 1920–1930." *Journal of Southern History* 70(1): 113–142.

Kalipeni, Ezekiel and Paul T. Zeleza (eds). 1999. *Sacred Spaces and Public Quarrels: African Cultural and Economic Landscapes*. Trenton, NJ: Africa World Press.

Kateb, George. 2011. *Human Dignity*. Cambridge, MA: Belknap Press of Harvard University Press.

Kelly, Kate. 2014. "The Green Book: The First Travel Guide for African-Americans Dates to the 1930s." *Huffington Post*, January 6. www.huffingtonpost.com/kate-kelly/the-green-book-the-first_b_4549962.html.

Kendi, Ibram X. 2016. *Stamped from the Beginning: The Definitive History of Racist Ideas in America*. New York: Nation Books.

Kennedy, Richard A. 2013. "Auto Mobility, Hospitality, African American Tourism and Mapping Victor H. Green's Negro Motorist Green Book." Master's thesis, East Carolina University.

Krymkow, Daniel H., Robert E. Manning, and William Valliere. 2014. "Race, Ethnicity, and Visitation to National Parks in the United States: Tests of the Marginality,

Discrimination, and Subculture Hypotheses with National-Level Survey Data." *Journal of Outdoor Recreation and Tourism* 7/8: 35–43.

Landers, Jane. 1999. *Black Society in Spanish Florida*. Champaign: University of Illinois Press.

Landrum, Ney C. 2004. *The State Park Movement in America: A Critical Review*. Columbia, MO: University of Missouri Press.

Lassiter, Luke Eric (ed.). 2004. *The Other Side of Middletown: Exploring Muncie's African American Community*. Walnut Creek, CA: Altamira Press.

Leone, Mark P. and Parker B. Potter Jr. (eds). 1988. *The Recovery of Meaning: Historical Archaeology in the Eastern United States*. Washington, DC: Smithsonian Institute Press.

Levin, Kevin M. 2017. "When it comes to historical markers, every word matters." *Smithsonian.com*, July 6. Accessed December 19, 2018. www.smithsonianmag.com/history/when-it-comes-historical-markers-every-word-matters-180963973/.

Library of Congress. 1945. "Federal Register: 10 Fed. Reg. 14855 (Dec. 8, 1945)." Accessed March 15, 2018. www.loc.gov/item/fr010240/.

Lipsitz, George. 2007. "The Racialization of Space and Spatialization of Race." *Landscape Journal* 26(1): 10–23.

Lipsitz, George. 2011. *How Racism Takes Place*. Philadelphia, PA: Temple University Press.

Littlefield, Daniel C. 1991[1981]. *Rice and Slaves: Ethnicity and the Slave Trade in Colonial South Carolina*. Urbana: University of Illinois Press.

Louv, Richard. 2008. *Last Child in the Woods: Saving Our Children from Nature Deficit Disorder*. Chapel Hill, NC: Algonquin Books.

Lowman, Iyshia. 2012. "Jim Crow at the Beach: An Oral and Archival History of the Segregated Past at Homestead Bayfront Beach." BISC Acc. 413. National Park Service. Biscayne National Park, Homestead, Florida. Accessed February 16, 2019 via USF Heritage Research Lab site. https://heritagelab.org/?p=1884 and www.heritagelab.org.

Lowman, Iyshia Michelle. 2014. "Recreational Segregation: The Role of Place in Shaping Communities." MA thesis, University of South Florida.

Lynd, Robert S. and Helen M. Lynd. 1929. *Middletown: A Study in Contemporary African Culture*. New York: Harcourt, Brace, & Co.

Lyons, Joy Medley. 2006. *Making Their Mark: The Signature of Slavery at Mammoth Cave*. Fort Washington: Eastern National.

Marsalis, Ellis L. Sr. 1998. Ellis Marsalis Sr., September 15, 1988 interview with Dr. Lawrence Powell from the Tulane University History Department. In Ellis L. Marsalis Sr. Papers, 1952–1999. Amistad Research Center, New Orleans, Louisiana (Diane Galatowitsch, collection curator).

Martin, Derek Christopher. 2004. "Apartheid in the Great Outdoors: American Advertising and the Reproduction of a Racialized Outdoor Leisure Identity." *Journal of Leisure Research* 36(4): 513–535.

Mason, Gilbert R. with James Patterson Smith. 1998. *Beaches, Blood, and Ballots: A Black Doctor's Civil Rights Struggles*. Jackson: University of Mississippi Press.

McGranahan, Carole. 2016. "Refusal and the Gift of Citizenship." *Cultural Anthropology* 31(3): 334–341.

McGrew, J. H. 1927. *A Study of Negro Life in Tampa*. Florida Collection, 975.965 S933. State Library of Florida.

McKittrick, K. 2006. *Demonic Grounds: Black Women and Cartographies of Struggle*. Minneapolis: University of Minnesota Press.

McQueeney, Kevin G. 2015. "Playing with Jim Crow: African American Private Parks in Early Twentieth Century New Orleans." Paper 1989, University of New Orleans Theses and Dissertations.

Mintz, Sidney W. 1985. *Sweetness and Power: The Place of Sugar in Modern History*. New York: Elisabeth Sifton Books and Penguin Books.

Mock, Brentin. 2014. "How African Americans Beat One of the Most Racist Institutions: The Swimming Pool." *The Grist*, May 28. Accessed September 27, 2018, http://grist.org/living/how-african-americans-beat-one-of-the-most-racist-institutions-the-swimming-pool/.

Mock, Brentin. 2016. "For African Americans, Park Access Is About More Than Just Proximity." *CityLab*, June 2. Accessed February 16, 2019. www.citylab.com/design/2016/06/for-african-americans-park-access-is-about-more-than-just-proximity/485321/.

Mondal, Puja. n.d. "Social Exclusion: Definition, Mechanisms and Impact of Social Exclusion." Accessed August 17, 2018. www.yourarticlelibrary.com/sociology/social-exclusion-defini tion-mechanisms-and-impact-of-social-exclusion/31424/.

Myrdal, Gunnar. 1944. *An American Dilemma*. New York: Harper & Bros.

Nash, L. 1956. *Travelguide: Vacation and Recreation Without Humiliation*. New York: Travelguide, Inc.

National Park Service Bransfords Site Bulletin. N.d. "The Bransfords of Mammoth Cave." Accessed December 14, 2018. www.nps.gov/maca/planyourvisit/upload/Bransfords%20S ite%20Bulletin.PDF.

National Parks Second Century Commission. 2010. "Advancing the National Park Idea." *National Park Service*. Accessed January 21, 2017. www.nps.gov/civic/resources/Comm ission_Report.pdf.

National Park Service. N.d. "Timucuan Ecological and Historic Preserve Draft Environ-mental Assessment—Kingsley Plantation-Ribault Club Interpretation Tram Tour." Accessed June 1, 2018. https://parkplanning.nps.gov/projectHome.cfm?projectID= 26259.

National Park Service. 1996. "General management plan, development concept plans, Timucuan Ecological and Historic Preserve, NPS D-7B." *National Park Service*, Denver Service Center.

National Park Service. 2016a. "National Register of Historic Places Registration Form." 2016. *Kingsley Plantation Historic District Additional Documentation*. Accessed June 1, 2018. www.nps.gov/nr/feature/places/pdfs/AD_70000182_11_08_2016.pdf.

National Park Service. 2016b. "State of the Park Report for Timucuan Ecological and Historic Preserve and Fort Caroline National Memorial." State of the Park Series No. 39. *National Park Service*, Washington, DC. Accessed November 25, 2018. www.nps.gov/na ture/state-of-the-park.htm.

National Park Service. 2018a. "Timucuan Ecological and Historic Preserve (TIMU) web-site." Last modified July 22, 2018. Accessed November 25, 2018. www.nps.gov/timu/index.htm.

National Park Service. 2018b. "Timucuan Ecological and Historic Preserve (TIMU) web-site." Accessed June 28, 2018. www.nps.gov/timu/learn/historyculture/kp_hotel_clubs.htm.

National Park Service. 2018c. "Black History at Mammoth Cave." Mammoth Cave (MACA) website. Last modified August 19, 2018. Accessed September 13, 2019. www.nps.gov/maca/learn/historyculture/black-history.htm.

National Park Service. 2019. "Park Management Documents." Mammoth Cave (MACA) website, www.nps.gov/maca/index.htm. Last modified February 6, 2019. Accessed September 13, 2019.

O'Brien, William. 2007. "The Strange Career of a Florida State Park: Uncovering a Jim Crow Past. *Historical Geography* 35: 160–184.

O'Brien, William E. 2012. "State Parks and Jim Crow in the Decade Before *Brown v. Board of Education*." *Geographical Review* 102(2): 166–179.

Odom, P. H. 1911. Charter and Ordinances of the City of Jacksonville. *City Council of Jacksonville 1909–1991*, Jacksonville, FL.

Ohlson, Kristin. 2006. "The Bransfords of Mammoth Cave." *American Legacy*, Spring: 17–24. Accessed December 14, 2018. www.kristinohlson.com/files/mammoth_cave-2.pdf.

Orser, Charles E. Jr. 2007. *The Archaeology of Race and Racialization in Historic America (The American Experience in Archaeological Perspective).* Gainesville: University Press of Florida.

Otero, Lydia. 2010. *La Calle: Spatial Conflicts and Urban Renewal in a Southwest City.* Tucson: University of Arizona Press.

Parker, Nancy. 2015. "Marsalis Mansion Owner Leaves Legacy of Giving." *FOX 8 News*, January 9. Accessed December 19, 2018. www.fox8live.com/story/27808171/marsa lis-mansion-owner-leaves-a-legacy-of-giving.

Parks, Cynthia. 1988. "Life Along the River Stayed Simple Until the Bridge Came Along." *Florida Times/ Jacksonville Journal*, September. Accessed January 5, 2020. http://fl-genweb. org/duval/towns/granddame.html.

Patrick, Rembert W. and Allen Morris. 1967. *Florida Under Five Flags*, 4th ed. Gainesville: University of Florida Press.

Pauly, Megan. 2017. "History Matters: A Segregation-era Travel Guide for African Americans." *Delaware Public Media, Morning Edition*, June 2. Accessed June 1, 2018. www.tinyurl.com/ ydf8rqx6.

Phelts, Marsha D. 1997. *An American Beach for African Americans.* Gainesville: University Press of Florida.

Phelts, Marsha D. 2001. "Interview with Antoinette T. Jackson, Amelia Island, Florida, August 25." In *Ethnohistorical Study of Kingsley Plantation Community*, by Antoinette Jackson with Allan F. Burns, 28–30. Atlanta, GA: Cultural Resources Division, Southeast Regional Office, National Park Service.

Philip, Steven. 2000. "Race and the Pursuit of Happiness." *Journal of Leisure Research* 32(1): 121–124.

Pinn, Anthony B. 2008. *The African American religions experience in America.* Gainesville: University Press of Florida.

Polanco, Mieka Brand. 2014. *Historically Black: Imagining Community in a Black Historic District.* New York and London: New York University Press.

Quinlan, Adriane. 2014. "Do you Remember the Marsalis Mansion Motel." *NOLA.com/ The Times-Picayune*, December 31. Accessed December 19, 2018. www.nola.com/poli tics/index.ssf/2014/12/do_you_remember_the_marsalis_m.html.

Quinlan, Adriane. 2015. "With a River Road Historical Marker Ellis Marsalis Sr. Gets His Due." *NOLA.com/The Times-Picayune*, January 8. Accessed February 16, 2019. www. nola.com/politics/index.ssf/2015/01/marsalis_mansion_motel_honored.html.

Quinlan, Adriane. 2015. "Marsalis Musical Clan's Patriarch Toots His Own Horn—For the First Time." *NOLA.com/The Times-Picayune*, January 9. Accessed February 16, 2019. www.nola.com/politics/index.ssf/2015/01/ellis_marsalis_sr_marker_cerem.html.

Raper, Arthur, J. H. McGrew, and B. E. Maya. 1927. "A Study of Negro Life in Tampa 1927." Report prepared by the YMCA, the Urban League, and the Interracial Commission. Accessed January 5, 2019. www.floridamemory.com/items/show/326639?id=78.

Reed, Germaine A. 1965. "Race Legislation in Louisiana: 1864–1920." *Louisiana History: Journal of the Louisiana Historical Association* 6(4): 379–392.

Regis, Helen A. 2001. "Blackness and the Politics of Memory in the New Orleans Second Line." *American Ethnologist* 28(4): 752–777.

Renkema, W. E. 1979. "Between Slavery and Freedom: Ex-slaves as Wage-labourers on Plantations of Curaçao after 1863." Paper presented at the Eleventh Conference of the Association of Caribbean Historians, Curaçao, April 1979.

Reut, Jennifer. 2012. "Mapping the Green Book." Accessed September 29, 2017. http://mappingthegreenbook.tumblr.com/post/158667610934/mgb-in-the-world.

Rogers Park website. "The History of Rogers Park." Accessed January 5, 2018. www.rogersparkgolf.net/history/.

Rosengarten, David. 2014. "The Real Deal Meal in Curaçao." *Forbes*, September 16. www.forbes.com/sites/drosengarten/2014/09/16/the-real-deal-meal-in-curacao/amp/.

Rothstein, Richard. 2017. *The Color of Law: The Forgotten History of How Our Government Segregated America*. New York: Liveright Publishing.

Rugh, Susan Sessions. 2008. *Are We There Yet? The Golden Age of American Family Vacations*. Lawrence: University Press of Kansas.

Savage, Barbara Dianne. 2008. *Your Spirits Walk Besides Us: The Politics of Black Religion*. Cambridge, MA: Belknap Press of Harvard University Press.

Scheinfeld, Marisa, Stefan Kanfer, and Jenna Weissman Joselit. 2016. *The Borscht Belt: Revisiting the Remains of America's Jewish Vacationland*. Ithaca, NY: Cornell University Press.

Schiavo, Laura Burd. 2016. "'White People Like Hiking': Some Implications of NPS Narratives of Relevance and Diversity." *Public Historian* 38(4): 206–235.

Schmitzer, Jeanne Cannella. 1995. "CCC Camp 510: Black Participation in the Creation of Mammoth Cave National Park." *Register of the Kentucky Historical Society* 93(4): 446–464.

Seiler, Cotton. 2006. "'So That We as a Race Might Have Something Authentic to Travel By': African American Automobility and Cold War Liberalism." *American Quarterly* 58(4): 1091–1117.

Semuels, Alana. 2016. "The Role of Highways in American Poverty: They Seemed Like Such a Good Idea in the 1950s." *The Atlantic*, March 18. Accessed January 5, 2019. www.theatlantic.com/business/archive/2016/03/role-of-highways-in-american-poverty/474282/.

Shabazz, Rashad. 2015. *Spatializing Blackness: Architectures of Confinement and Black Masculinity in Chicago*. Urbana: University of Illinois Press.

Shackel, Paul. 2002. *Memory in Black and White*. New York: Altamira Press.

Shumaker, Susan. 2009. "Segregation in the National Parks, Part 1." In *Untold Stories from America's National Parks*, edited by Susan Shumaker, Ken Burns, and Dayton Duncan. Accessed May 5, 2017. www.pbs.org/nationalparks/untold-stories/.

Sides, Josh. 2003. *L.A. City Limits: African American Los Angeles from the Great Depression to the Present*. Los Angeles: University of California Press.

Silver, Hilary. 2007. "The Process of Social Exclusion: The Dynamics of an Evolving Concept." Working Paper 95, Chronic Poverty Research Centre (CPRC).

Simpson, Audra. 2007. "On Ethnographic Refusal: Indigeneity, 'Voice' and Colonial Citizenship." *Junctures* 9: 67–80.

Simpson, Audra. 2014. *Mohawk Interruptus: Political Life Across the Borders of Settler States*. Durham, NC: Duke University Press.

Simpson, Audra. 2016. "Consent's Revenge." *Cultural Anthropology* 31(3): 326–333.

Skene, Gordon. 2012. "Voice of the Democrats: Strom Thurmond at the 1948 Democratic Convention—July 14, 1948." *Past Daily*. Accessed October 5, 2017. http://pastdaily.com/2012/07/19/voice-of-the-dixiecrats-strom-thurmond-at-the-1948-democratic-convention-july-14-1948/.

Soergel, Matt. 2018a. "Manhattan Beach: A Resort for African-Americans Once Flourished in Hanna Park Dunes." *Florida Times Union*, *jacksonville.com*, May 4. Accessed November 25, 2018. www.jacksonville.com/news/20180504/manhattan-beach-resort-for-african-americans-once-flourished-in-hanna-park-dunes.

Soergel, Matt. 2018b. "Bringing Hermit of Gaot Island Back to Life." *Florida Times Union*, *jacksonville.com*, August 15. Accessed May 4, 2018. www.jacksonville.com/news/20180815/bringing-hermit-of-goat-island-back-to-life.

Soja, Edward W. 2010. *Seeking Spatial Justice*. Minneapolis and London: University of Minnesota Press.

Sorin, Gretchen Sullivan. 2009. "'Keep Going': African Americans on the Road in the Era of Jim Crow." PhD dissertation, State University of New York at Albany.

Spanish Land Grants. 1941. *Spanish Land Grants in Florida: Confirmed Claims*, vol. IV. Tallahassee, FL: State Library Board.

Spence, Mark David. 1999. *Dispossessing the Wilderness: Indian Removal and the Making of the National Parks*. New York: Oxford University Press.

Spillane, Courtney. 2007. "Reconstructing the Past: Heritage Research and Preservation Activities in Tampa Bay Communities." Master's thesis, University of South Florida.

SSNOP (Sulphur Springs Neighborhood of Promise). *Sulphur Springs Neighborhood and Key Places Map*. Prepared by the SSNOP Group. Accessed August 12, 2018. See: www.ssnop. org/our-community/.

Stodolska, Monika, Kimberly J. Shinew, Myron F. Floyd, and Gordon Walker. 2014. *Race, Ethnicity, and Leisure: Perspectives on Research, Theory, and Practice*. Champaign, IL: Human Kinetics.

Stowell, Daniel W. 1996. *Timucuan Ecological and Historic Preserve Historic Resource Study*. Atlanta, GA: National Park Service, Southeast Field Area.

Study the Past website. "Jim Crow Laws: Louisiana." Accessed August 18, 2019. www. studythepast.com/weekly/LouisianaCrow.html.

Taylor, Candacy. 2016. "The Roots of Route 66." *The Atlantic*, November 3. Accessed August 18, 2019. www.theatlantic.com/politics/archive/2016/11/the-roots-of-route-66/ 506255/.

Taylor, Dorceta E. 1989. "Blacks and the Environment: Towards an Explanation of the Concern and Action Gap between Blacks and Whites." *Environment and Behavior* 21(2): 175–205.

The Green Book of South Carolina. 2017. "A Travel Guide to S.C. African American Cultural Sites." Accessed September 29, 2017. https://greenbookofsc.com/.

Townsend, Jacinda. 2016. "How the Green Book Helped African-Americans Tourists Navigate a Segregated Nation." *Smithsonian Magazine*, April. Accessed November 23, 2018. www.smithsonianmag.com/smithsonian-institution/history-green-book-african-am erican-travelers-180958506/#dmRa4mYTAmZcyjey.99.

Trouillot, Michel-Rolph. 1995. *Silencing the Past: Power and the Production of History*. Boston, MA: Beacon Press.

Trouillot, Michel-Rolph. 1998. "Culture on the Edges: Creolization in the Plantation Context." *Plantation Society in the Americas* 5(1): 8–28.

United Nations Educational, Scientific and Cultural Organization (UNESCO). 2017. "'Remembering Slavery' Poster Exhibition is On Display in Curaçao." *UNESCO Office in Kingston*, October 4. www.unesco.org/new/en/kingston/about-this-office/single-view /news/remembering_slavery_poster_exhibition_is_on_display_in/.

United Nations Human Rights Office of the High Commissioner. 2014. "Statement by the United Nations' Working Group of Experts on People of African Descent, on the conclusion of its official visit to the Kingdom of the Netherlands, 26 June–4 July 2014." *OHCHR*, July 4. Accessed December 3, 2018. www.ohchr.org/EN/NewsEvents/Pages/ DisplayNews.aspx?NewsID=14840&LangID=E.

United States Census Bureau. 1860. *Census Rolls*, Duval County and St. Johns County, Florida.

United States Census Bureau. 1870. *Census Rolls*, Duval County and St. Johns County, Florida.

United States Census Bureau. 1880. *Census Roll*, Duval County, Florida.

United States Census Bureau. 1918. *Negro Population, 1790–1915*. Washington, DC: Government Printing Office.

United States Census Bureau. 1920. *Census Roll*, Duval County, Florida.

United States Census Bureau. 1935. *Negroes in the United States, 1920–1930*. Washington, DC: Government Printing Office.

United States Census Bureau. 2010. *Census Roll*, Tampa, Florida.University of Colorado, Boulder. 2014. "Race and Travel in the Jim Crow Era: A Historical Geography of Racialized Landscapes in the U.S." Last modified August 22, 2014. www.colorado.edu/ geography/foote/maps/assign/GreenGuide/greenguide.html.

Urry, John. 2002. *The Tourist Gaze*, 2nd ed. Thousand Oaks, CA: Sage Publications.

Valenti, Andrew. 2018. "Former Marsalis Mansion Motel Site to Become Dog Day Care, Vet Clinic." *New Orleans City Business*, September 27. Accessed August 22, 2019. https:// neworleanscitybusiness.com/blog/2018/09/27/former-marsalis-mansion-motel-site-to-be come-dog-day-care-vet-clinic/.

Waller, Steven N. 2010. "Leisure in the Life of the 21st Century Black Church: Re-Thinking the Gift." *Journal of the Christian Society for Kinesiology and Leisure Studies* 1(1): 33–47.

Waller, Steven N. 2015. *Leisure and Fellowship in the Life of the Black Church: Theology and Praxis*. Bloomington, IN: Xlibris Self Publishing.

Washburne, Randel F. 1978. "Black Under-Participation in Wildland Recreation: Alternative Explanations." *Leisure Sciences* 1(2): 175–189.

Washington, Marsalis Yvette. 2016. Interview with author via phone, March 15.

Weber, Joe and Selima Sultana. 2013a. "The Civil Rights Movement and the Future of the National Park System in a Racially Diverse America." *Tourism Geographies* 15(3): 444–469.

Weber, Joe and Selima Sultana. 2013b. "Why Do So Few Minority People Visit National Parks? Visitation and Accessibility of 'America's Best Idea.'" *Annals of the Association of American Geographers* 103(3): 437–464.

Weems, Robert E. Jr. 1998. *Desegregating the Dollar: African American Consumerism in the Twentieth Century*. New York and London: New York University Press.

West, Patrick. 1993. "The Tyranny of Metaphor: Interracial Relationships, Minority Recreation, and the Wildland–Urban Interface." In *Culture, Conflict, and Communication in the Wildland-Urban Interface*, edited by A.W. Ewert, D. J. Chavez, and A. W. Magill, 109–115. Boulder CO: Westview Press.

West, Paul. 2010. "Trying the Dark: Mammoth Cave and the Racial Imagination." *Southern Spaces*, n.d. Accessed September 13, 2019. https://southernspaces.org/2010/trying-da rk-mammoth-cave-and-racial-imagination-1839%E2%80%931869.

Weyeneth, Robert R. 2005. "The Architecture of Racial Segregation: The Challenges of Preserving the Problematical Past." *Public Historian* 27(4): 11–44.

Whetstone, Walter. 2001. "Interview with Antoinette T. Jackson, Jacksonville, Florida, August 29." In *Ethnohistorical Study of Kingsley Plantation Community*, by Antoinette Jackson with Allan F. Burns, 34. Atlanta, GA: Cultural Resources Division, Southeast Regional Office, National Park Service.

Williams, Clay. 2001. "The Guide for Colored Travelers: A Reflection of the Urban League." *Journal of American and Comparative Cultures* 24(3–4): 71–79.

Wilson, Gertrude Rollins. n.d. "Notes Concerning the Old Plantation on Fort George Island: 1868–1869." Personal communications, on file at NPS Timucuan Preserve Office, Jacksonville, Florida.

Wilson, Mabel O. and Julian Rose. 2017. "Changing the Subject: Race and Public Space." *ARTFORUM* 55(10). Accessed July 23, 2019. www.artforum.com/print/201706/cha nging-the-subject-race-and-public-space-68687.

Wiltse, Jeff. 2007. *Contested Waters: A Social History of Swimming Pools in America*. Chapel Hill: University of North Carolina Press.

WKU KenCat Online Collections. Kentucky Museum Special Collections, Mammoth Cave. Accessed September 13, 2019. https://westernkentuckyuniversity.pastperfectonline. com/bysearchterm?keyword=Mammoth+Cave.

Wolcott, Victoria W. 2012. *Race, Riots, and Roller Coasters: The Struggle Over Segregated Recreation in America*. Philadelphia: University of Pennsylvania Press.

Wolf, Eric. 1997[1982]. *Europe and the People Without History*. Berkley: University of California Press.

Woodward, C. V. 1974. *The Strange Career of Jim Crow*. 3rd ed. New York: Oxford University Press.

Young, T. 2009. "'A Contradiction in Democratic Government': W.J. Trent, Jr. And the Struggle for Non-Segregated National Park Campgrounds." *Environmental History* 14(4): 651–682.

INDEX

Printed in the United States
by Baker & Taylor Publisher Services